CASE
FAST WIDE OPEN
ORIGINAL IMAGES

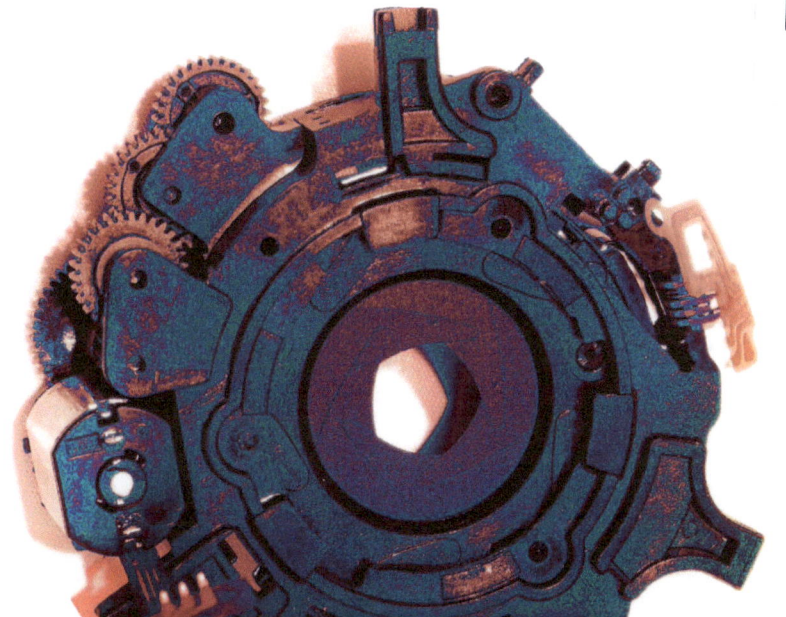

AN EXPLORATION OF PORTRAITURE, ARCHITECTURE, SETTING, TEXTURE AND VISUAL STORYTELLING
JUSTIN BLANEY
#1 BESTSELLING AUTHOR

Fast Wide Open

Copyright © 2014 by Justin R. Blaney. All rights reserved.
Printed in the United States of America by Inkliss Books, Seattle, Washington.
For information write Inkliss Books, 1941 1st Avenue South, Suite 2G, Seattle, WA 98134

Inkliss and the Inkliss logo are trademarks of Inkliss, an Oregon D.B.A. and are used by Justin Blaney and Company under license from Inkliss.

Library of Congress Cataloging-in-Publication Data Available

ISBN 978-1495335280 (paperback)
ISBN 978-1310332272 (ebook)
ISBN 978-0988251038 (hardback)

Cover design by Justin Blaney. Cover photo courtesy of Wikipedia, used with permission under the GNU Free Documentation License

First edition: January 2014

10 9 8 7 6 5 4 3 2 1

www.justinblaney.com

An
Justin Blaney
Book

FOR

NOW

WE

SEE

THROUGH

A

GLASS

DARKLY

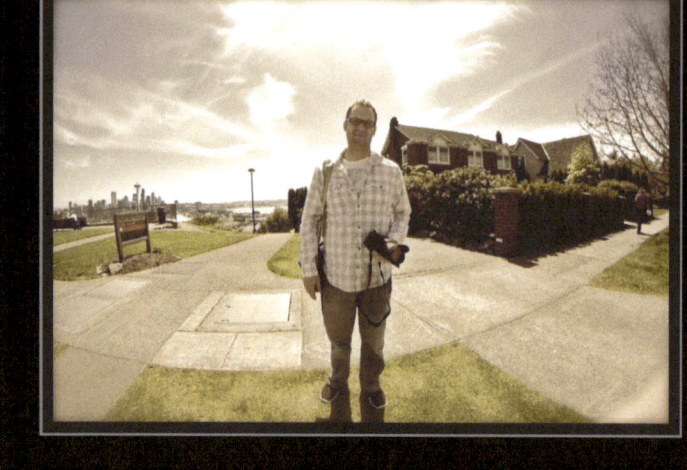

I LOVE TELLING STORIES

I've been earning a living—though sometimes it's been hard to call it that—from storytelling since I was sixteen years old selling vacuum cleaners door to door. Funnily enough, some of the stories I told back then were more fictional than the novels I write today.

Over the years, the mediums I've used have changed, but for me, it's always been about the story. Through blogging and songwriting and photography and speaking and design and sales, I've learned that the power of story is universal.

Today, I apply my passion to writing novels and producing films for nonprofits and businesses. Sometimes I'm trying to affect change in the world through fictional characters and magical adventures. Other times, I'm showing the world how my nonprofit and business clients are heroes in the lives of the people they serve. I'm often surprised to find that the real stories are even more magical than the fiction.

And that is why I created Fast Wide Open.

I realized many of the true stories that have inspired me over the last fifteen years were being held captive on my computer's hard drives. Whenever I see these images, I remember the way I felt when they were taken. I think of the people who allowed me to share for a small time the richness of their lives, the people who live or worship or play or learn in these places, the people who work these machines.

This book is not about pictures. It's about the fairytales inside them. These pictures are mere snapshots of real lives, but the snapshots give us a window through which we can dream for a short time that we are inside the fairytale. That we are someone else. And sometimes, every so often, a little bit of that dream rubs off on us, and when we wake, we find we're just a tiny bit changed.

I hope these stories inspire you as much as they inspire me.

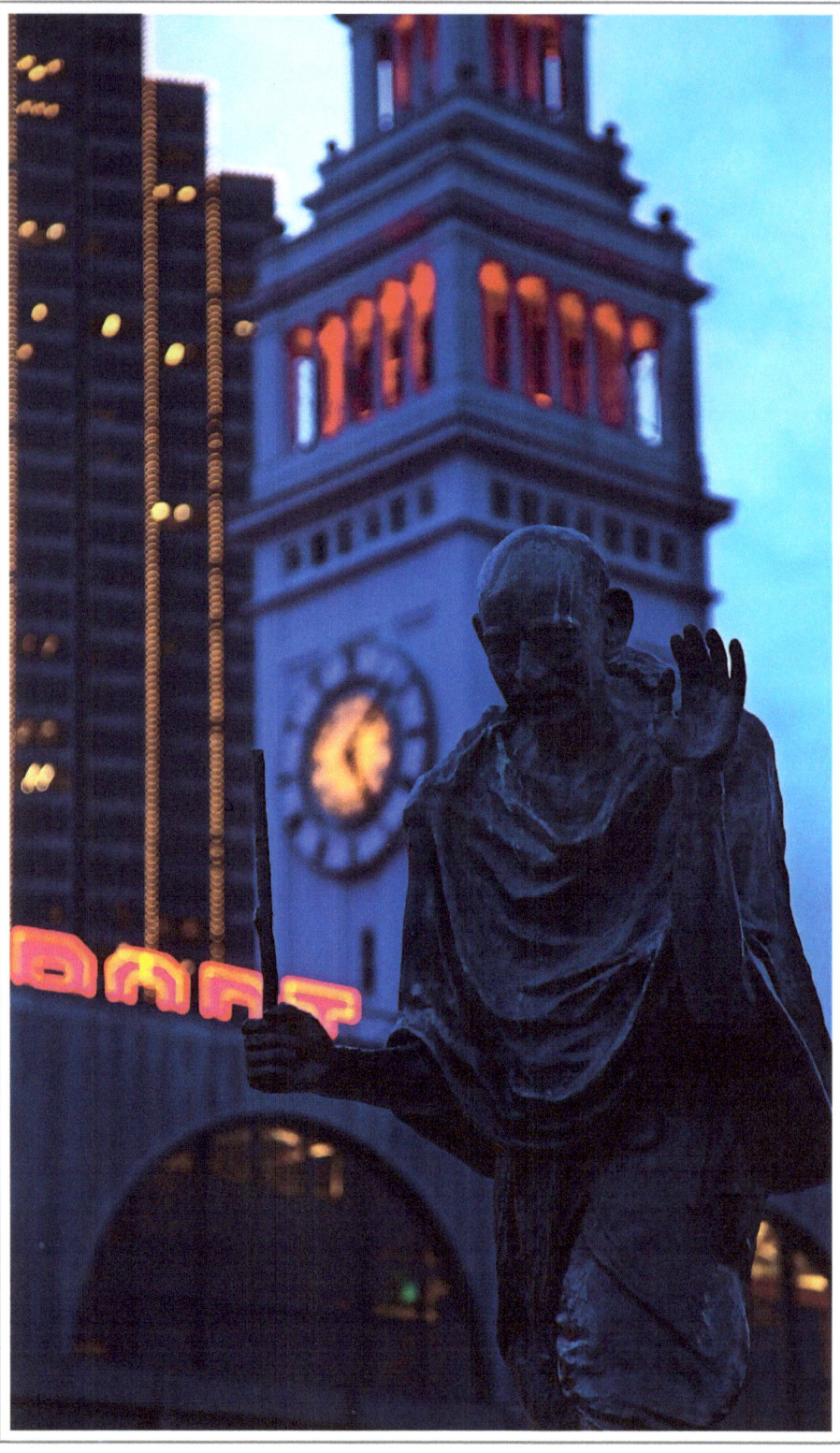

FERRY

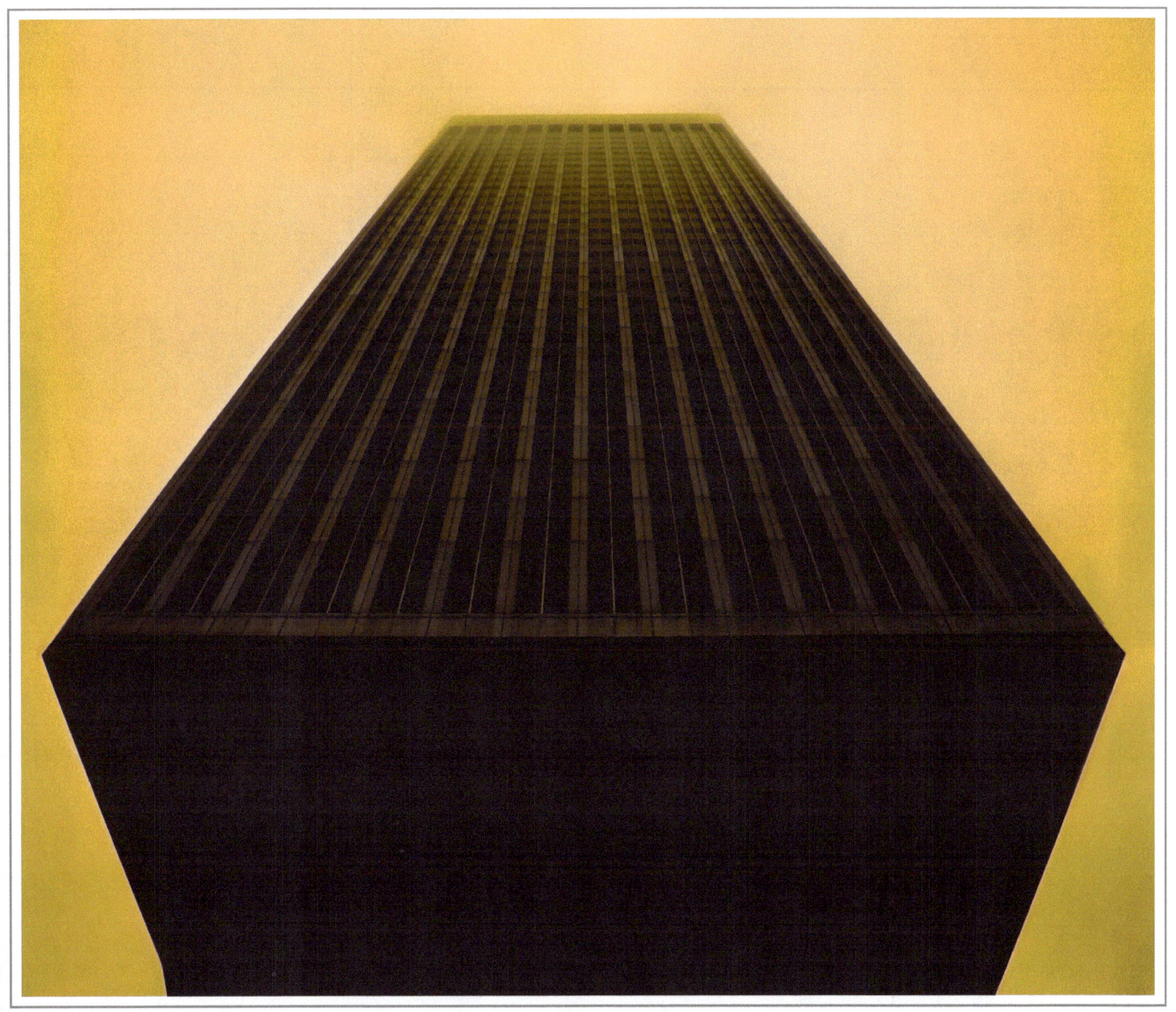

RAINIER

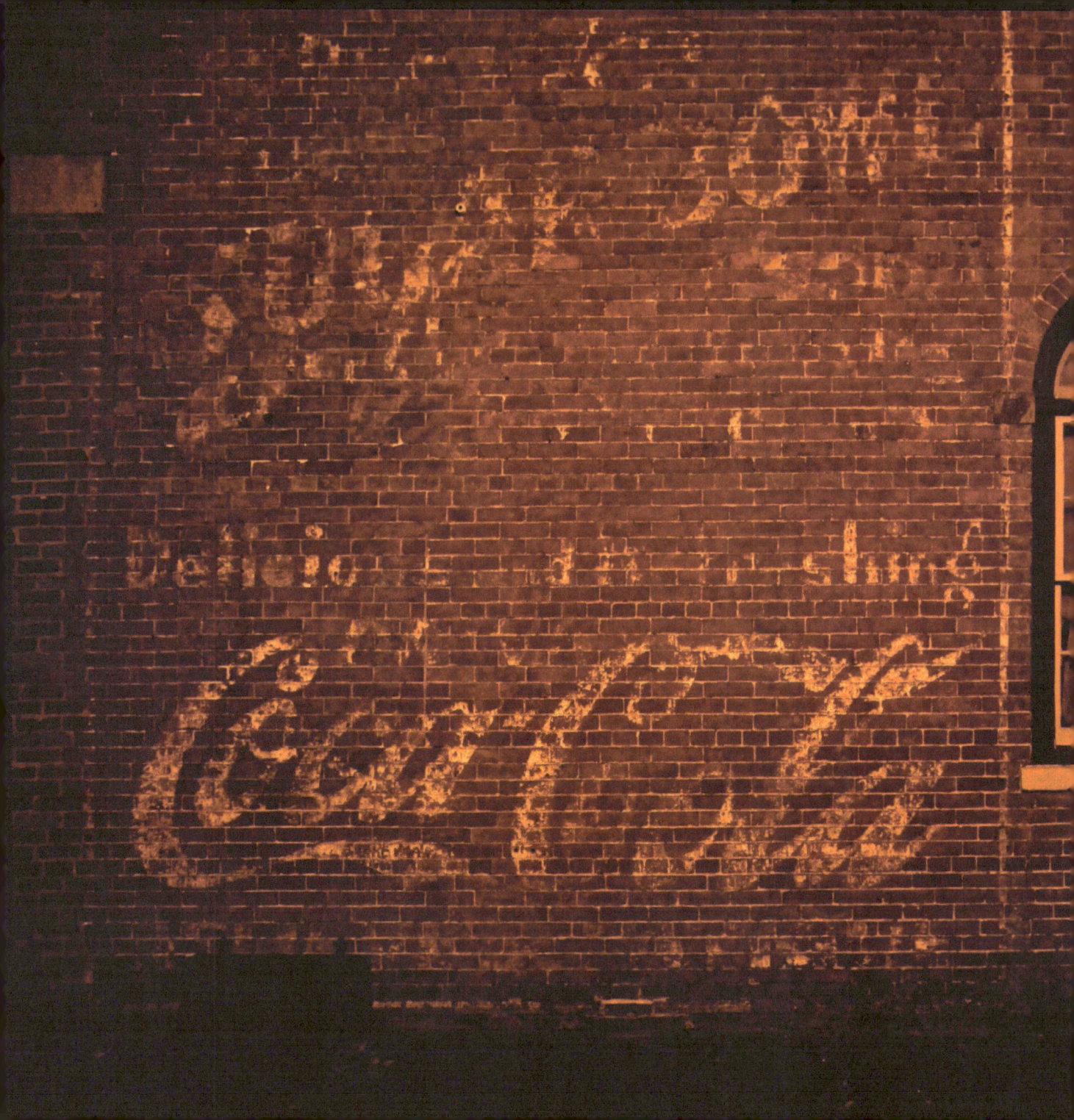

SMITH TOWER

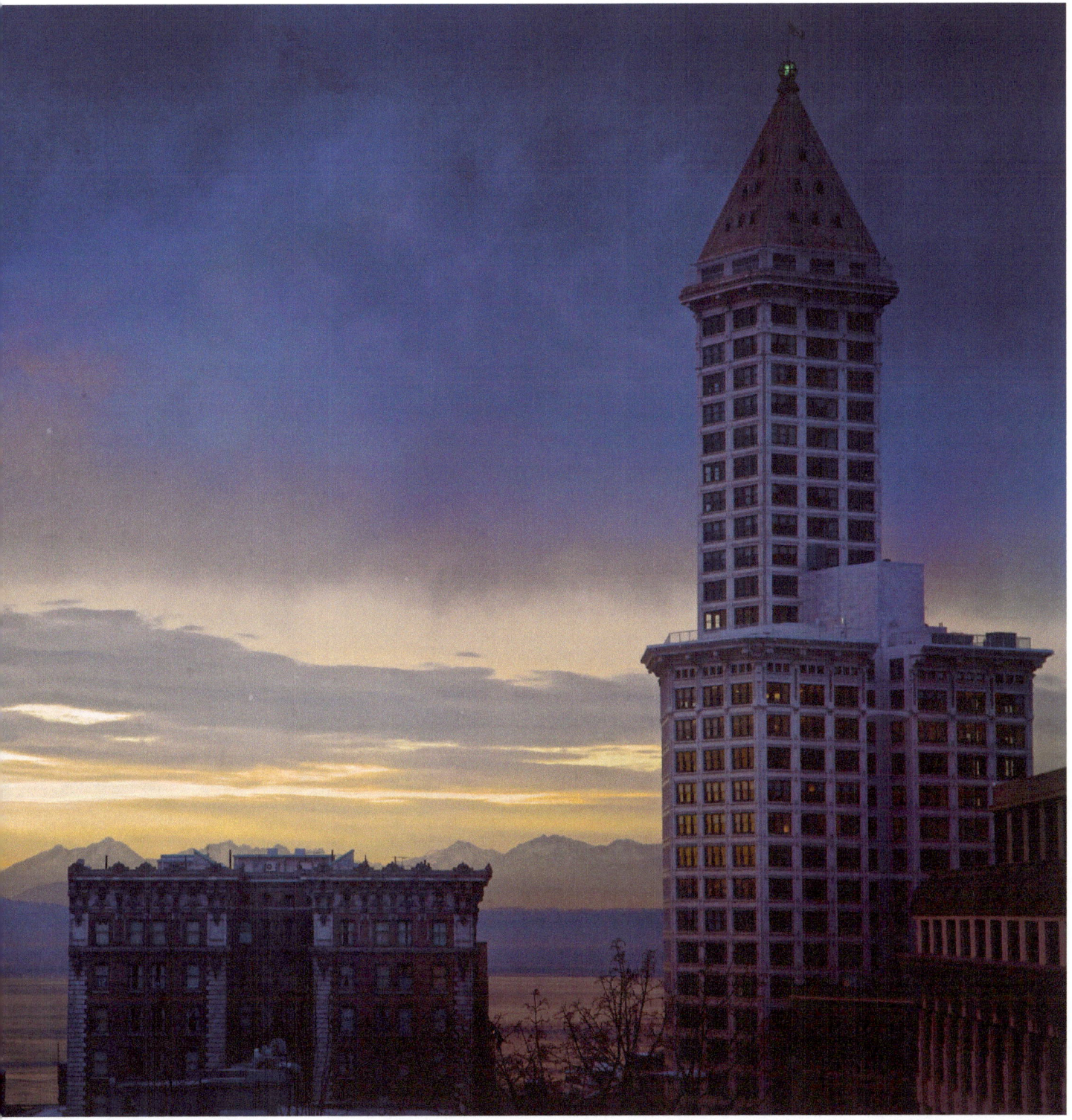

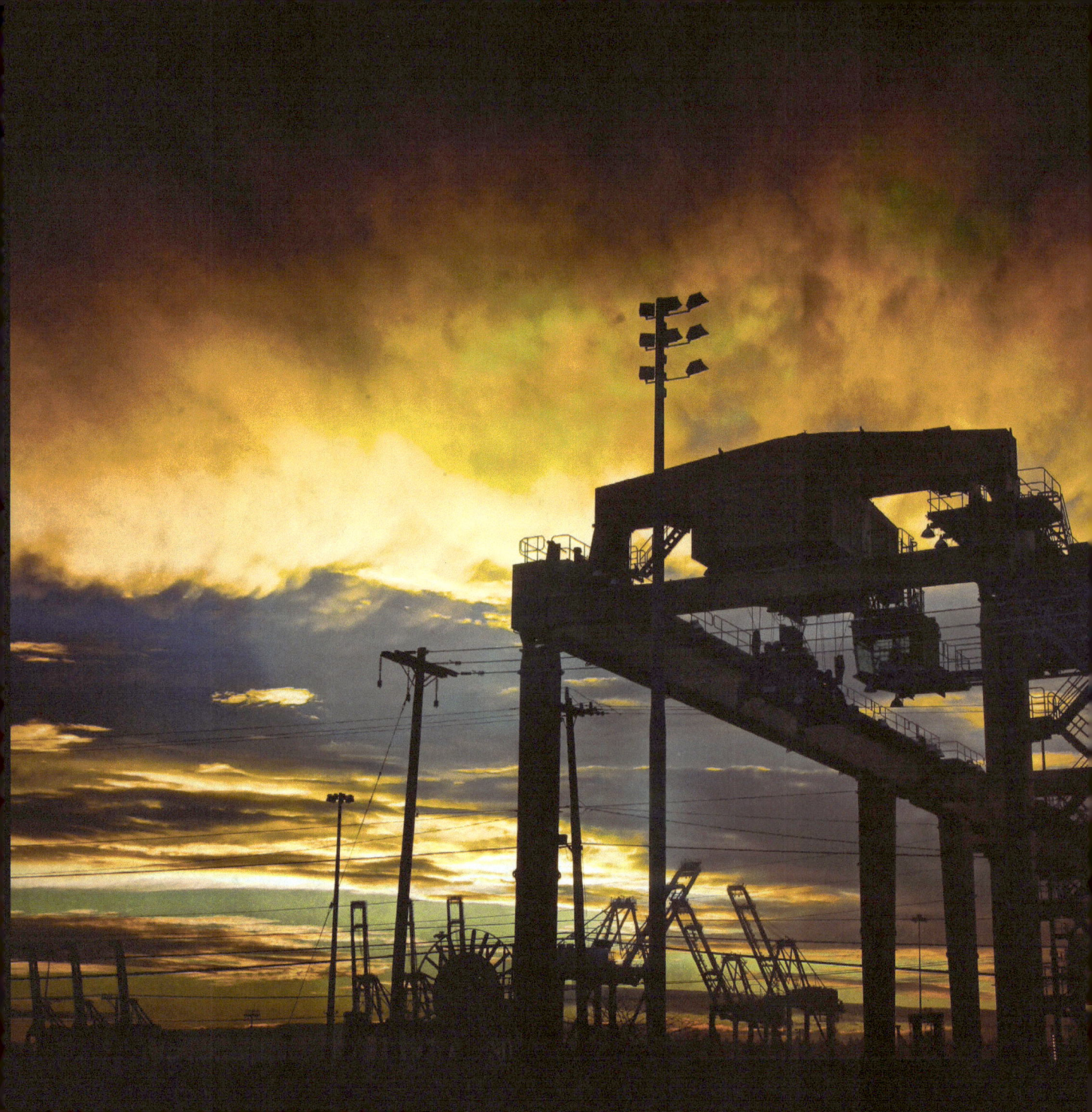

CRANES

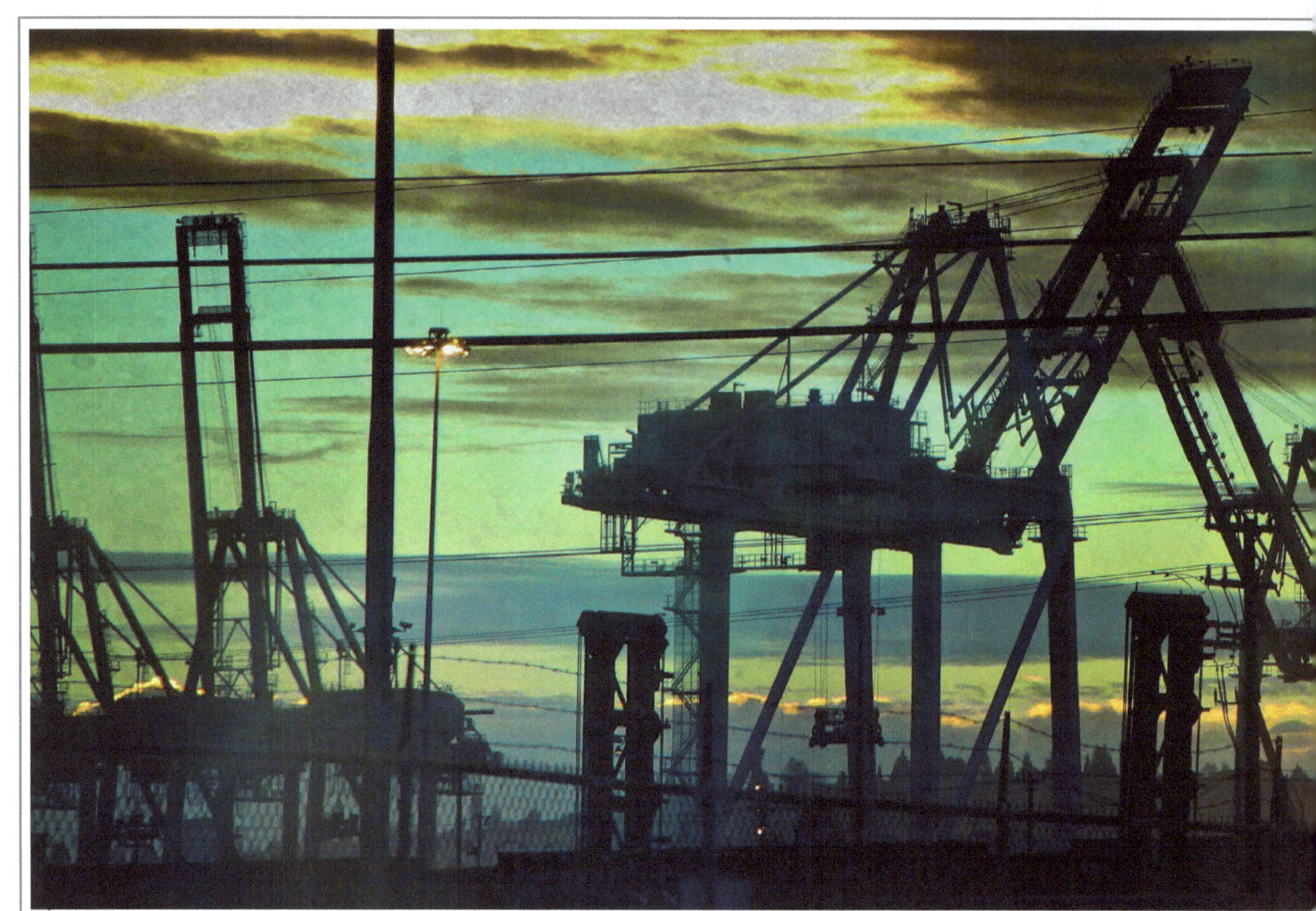

CRANES #2

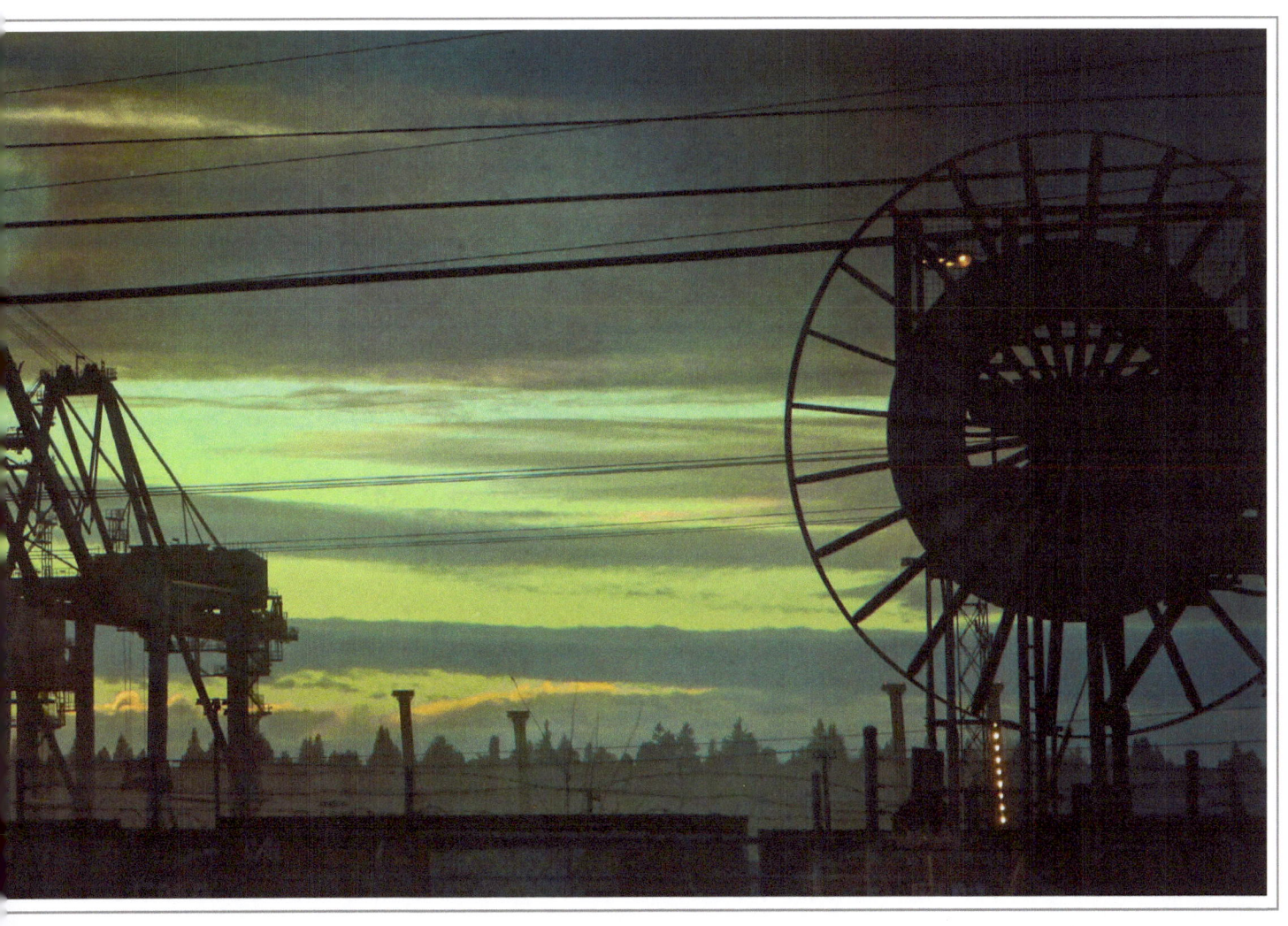

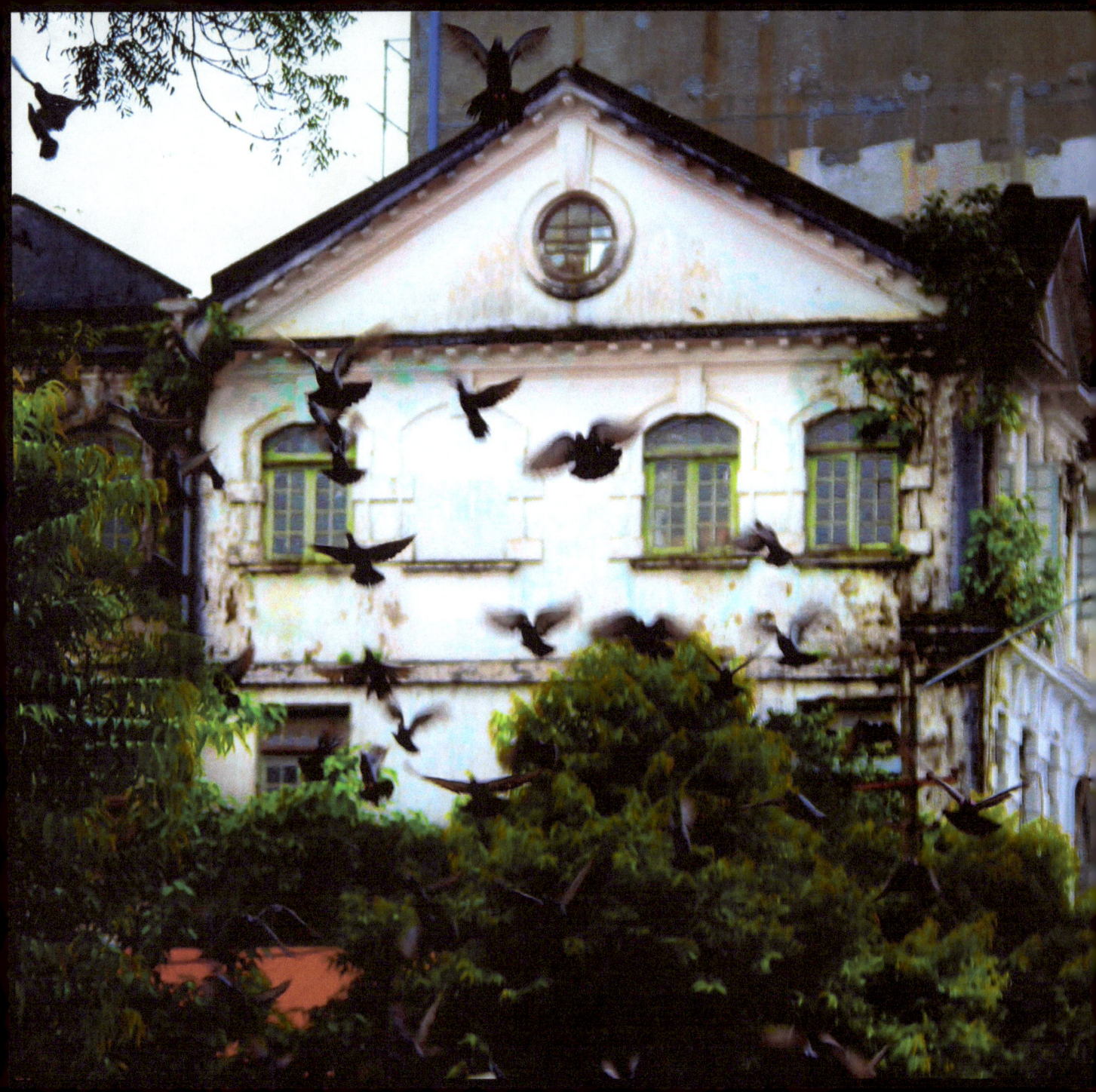

FLIGHT

COMM
UTE #1

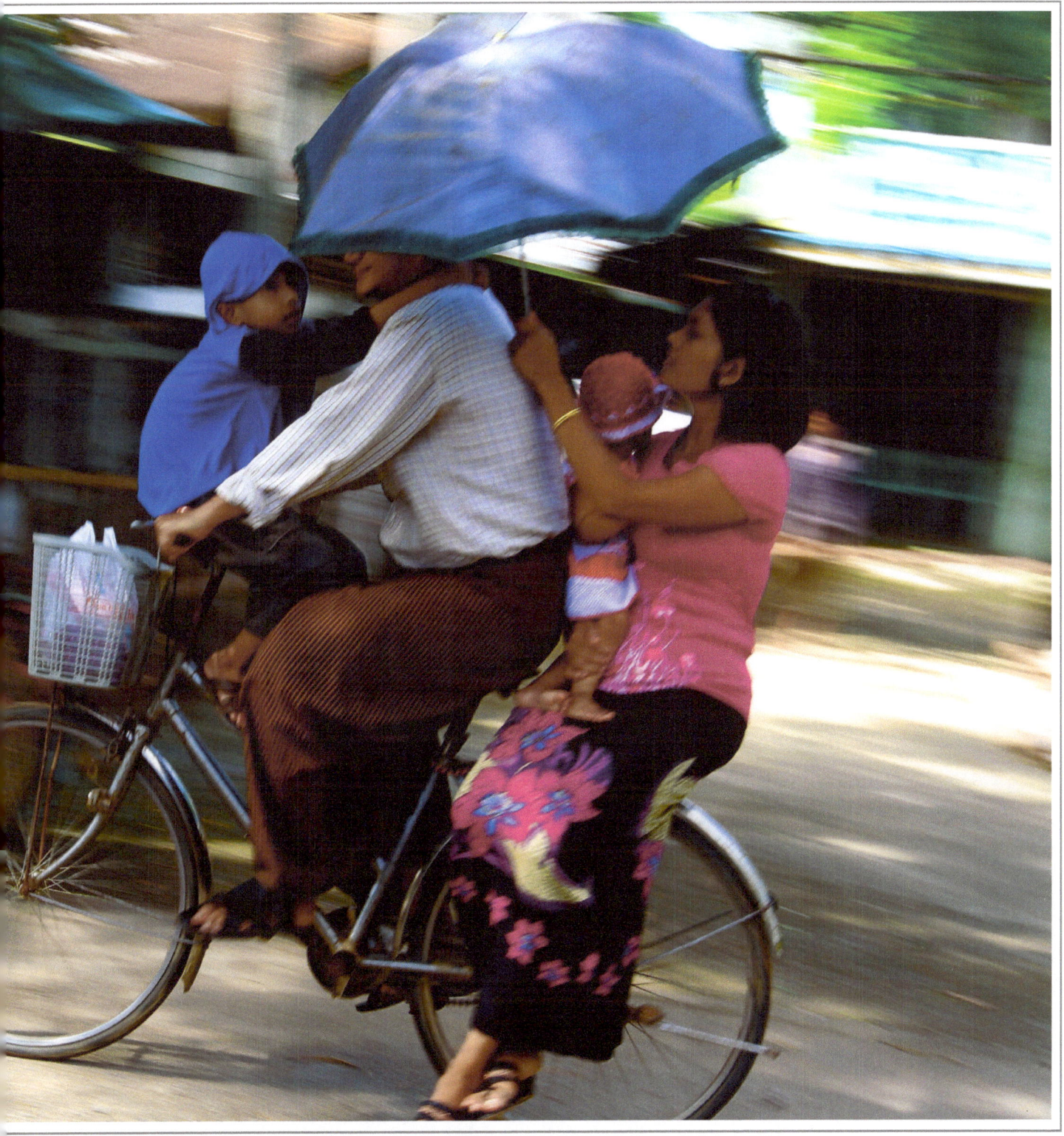

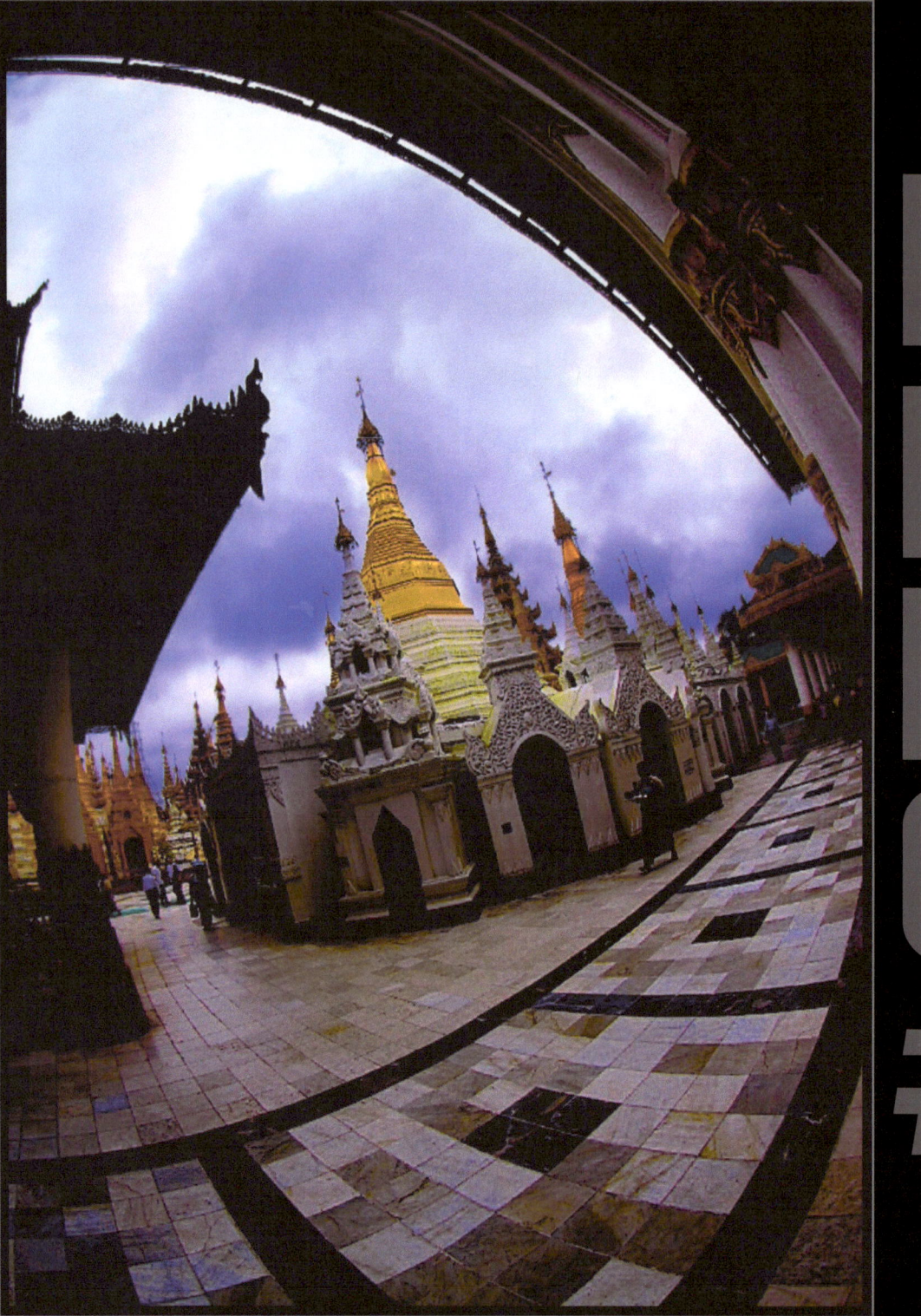

BAREFOOT #1

FARE

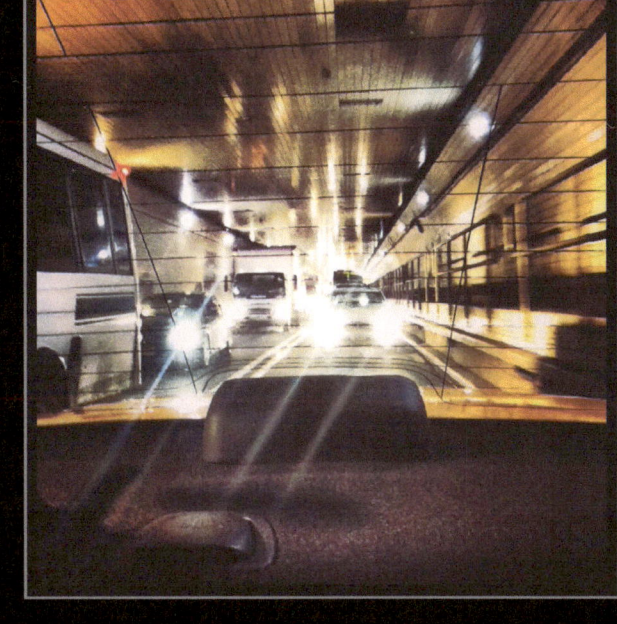

HOME #1

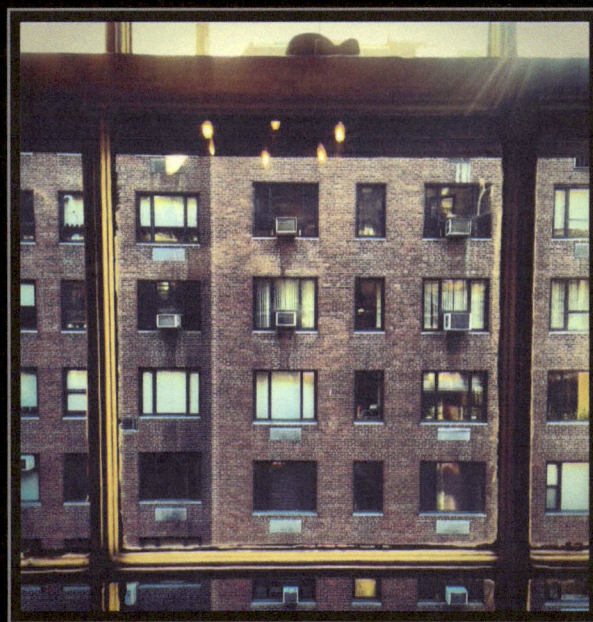

HOME #2

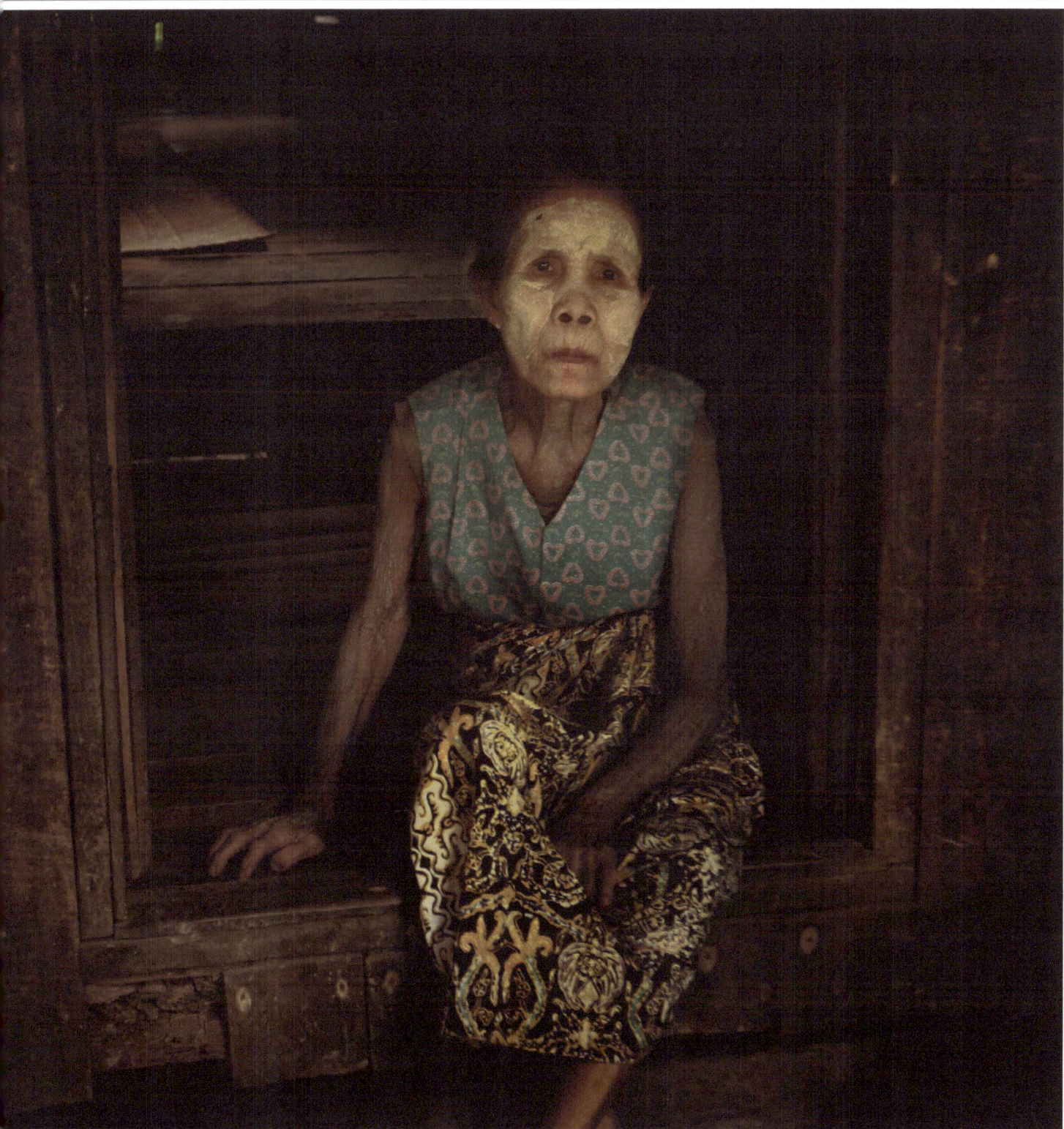

HOTEL POOL

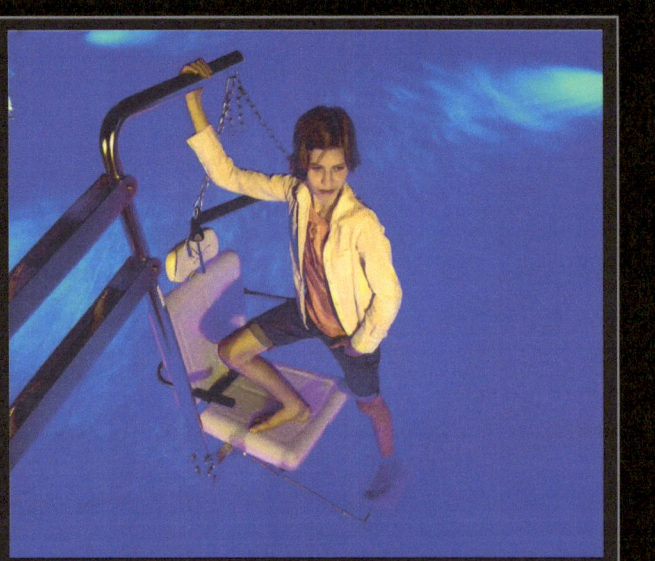

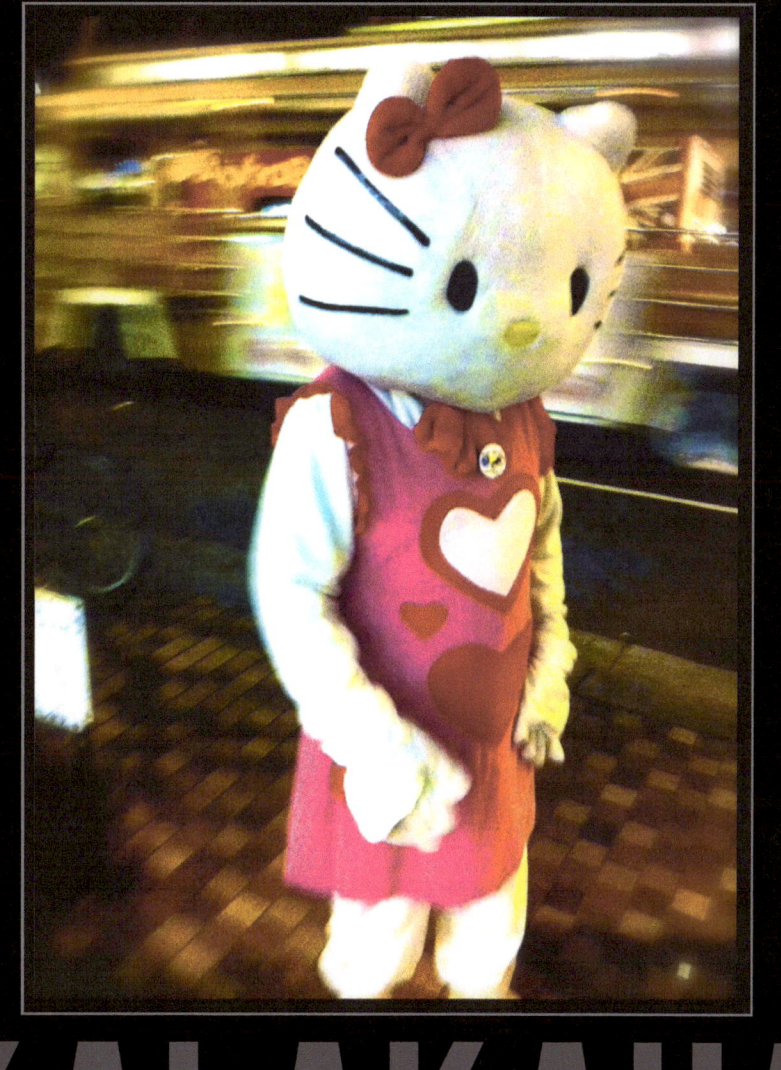

KALAKAUA

KEYS#1

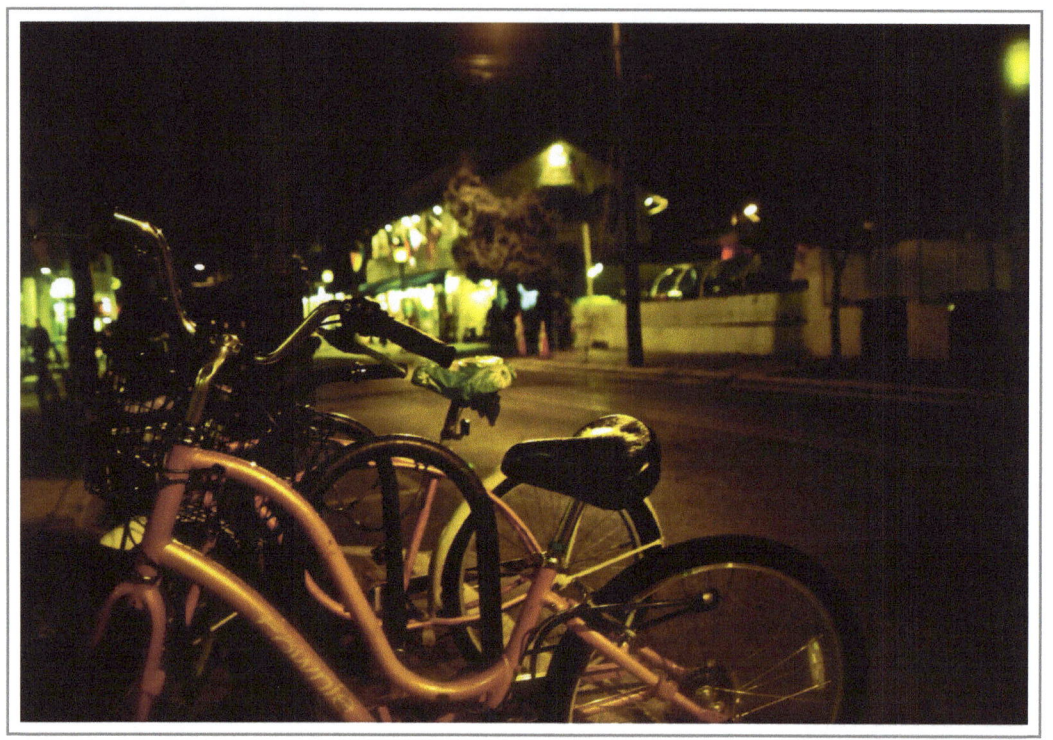

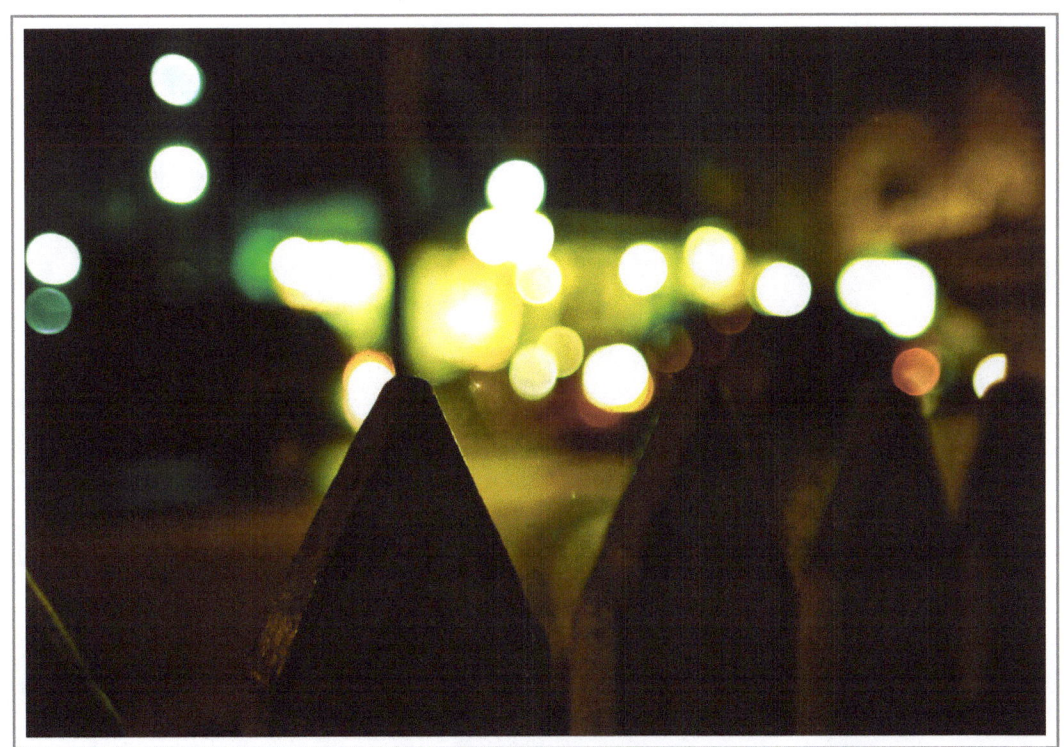

KEYS#2

GUM

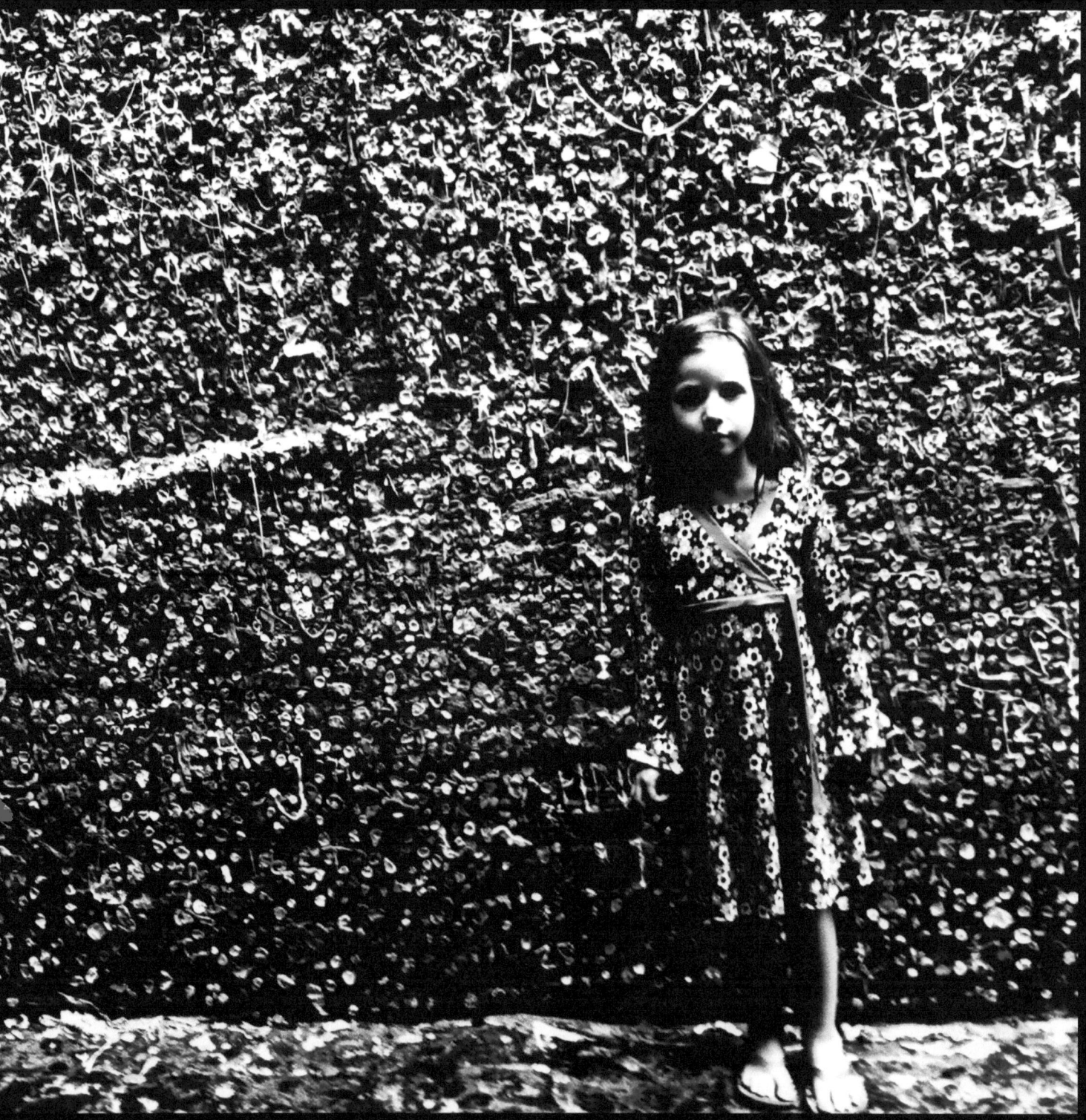

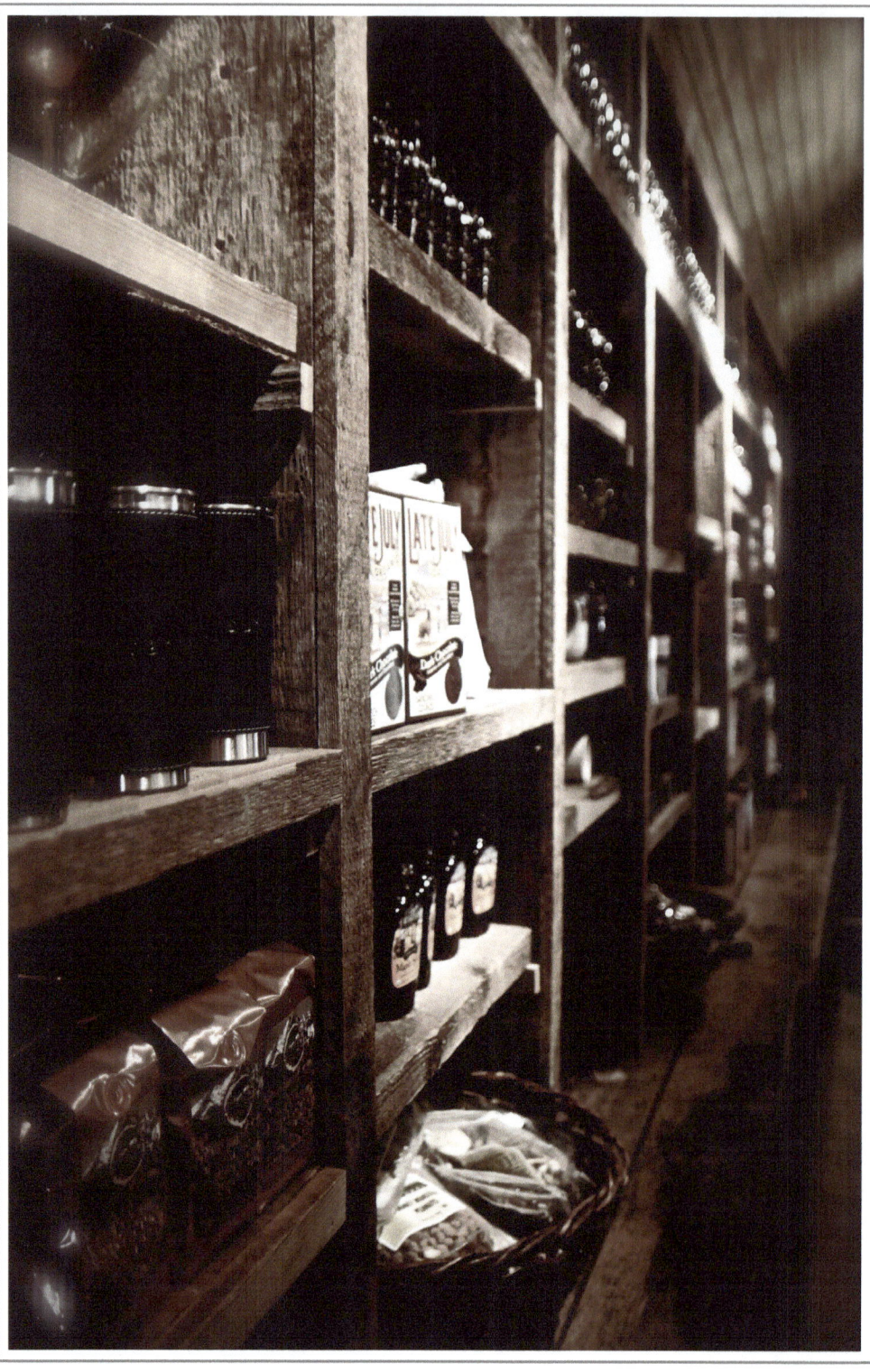

SUPPLY

BEACH

BRIDGE

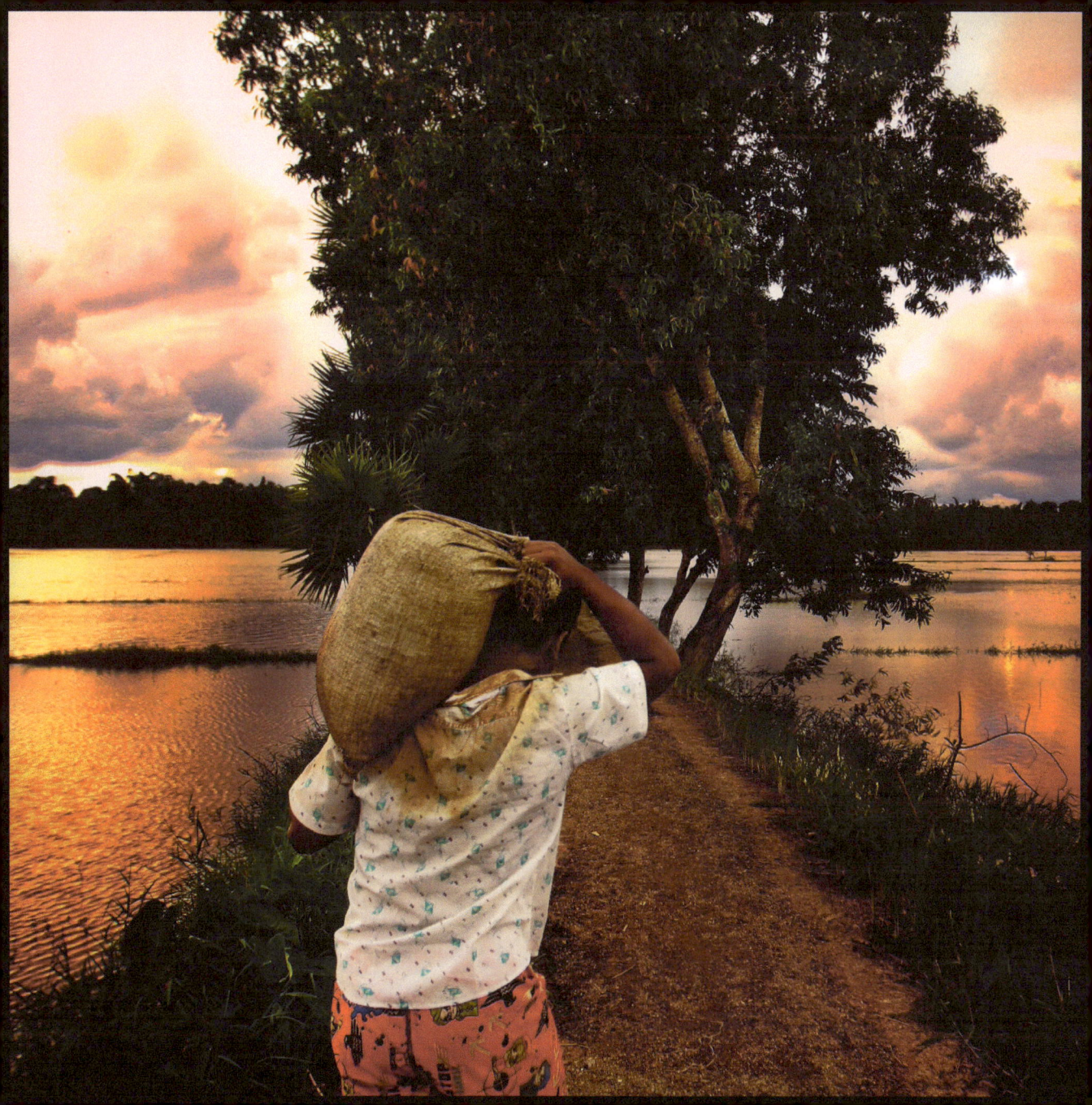

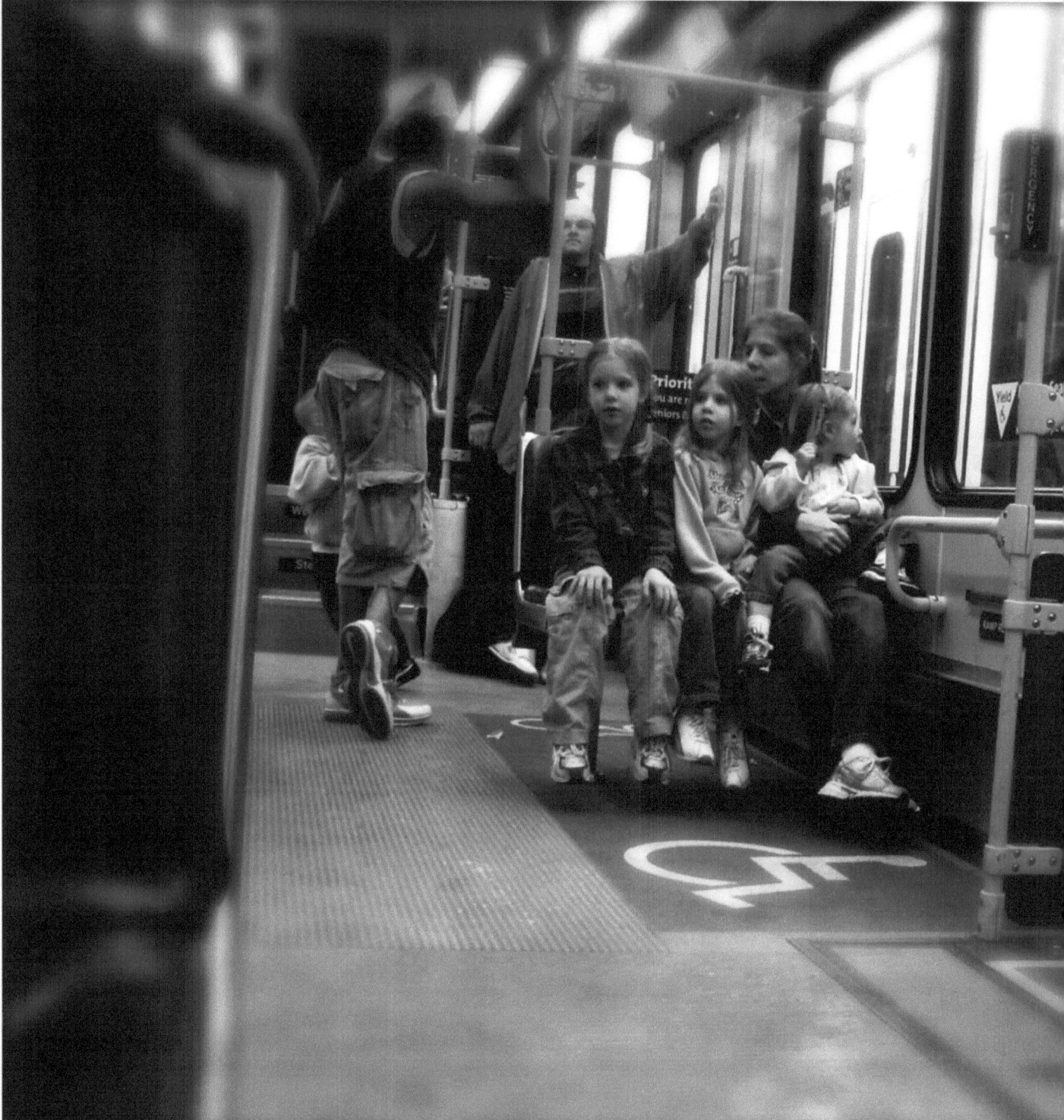

COMM
UTE#2

HO
ME
#3

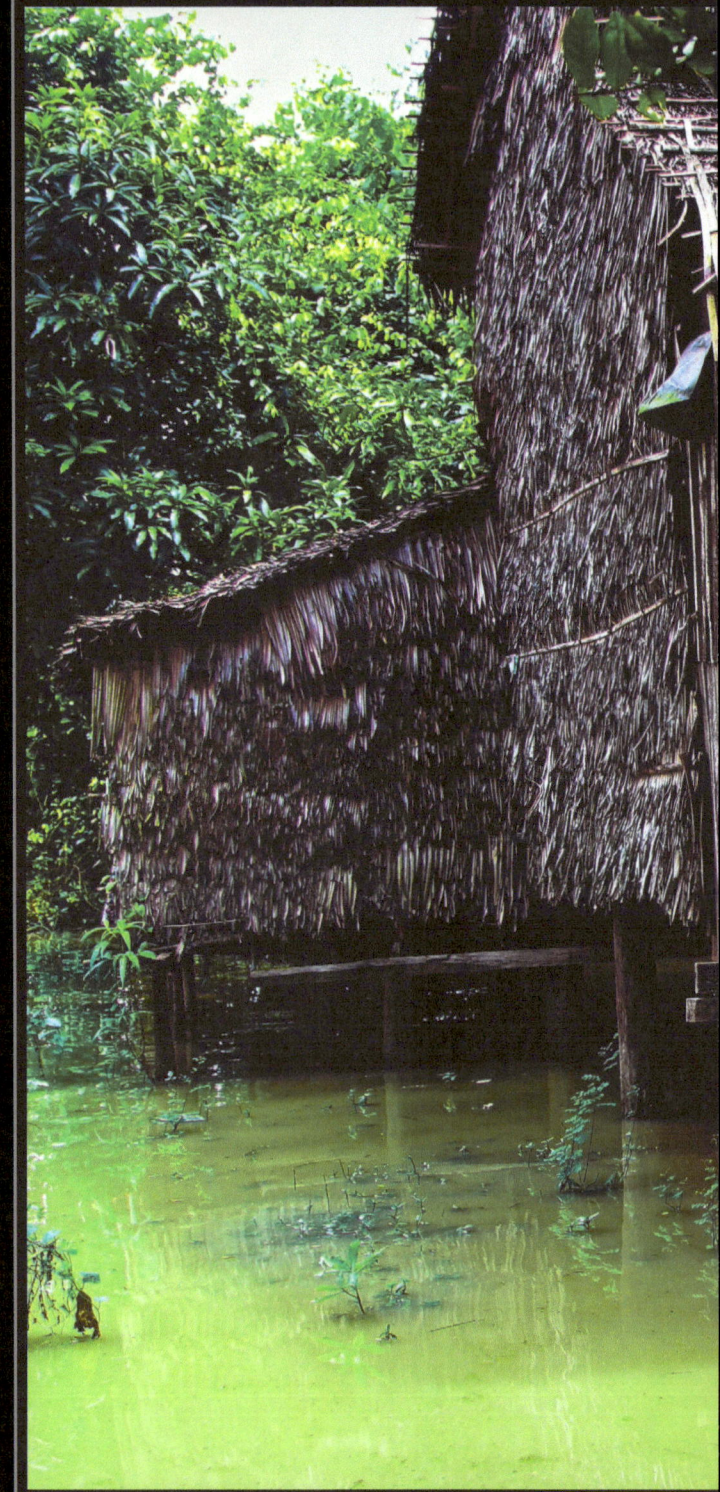

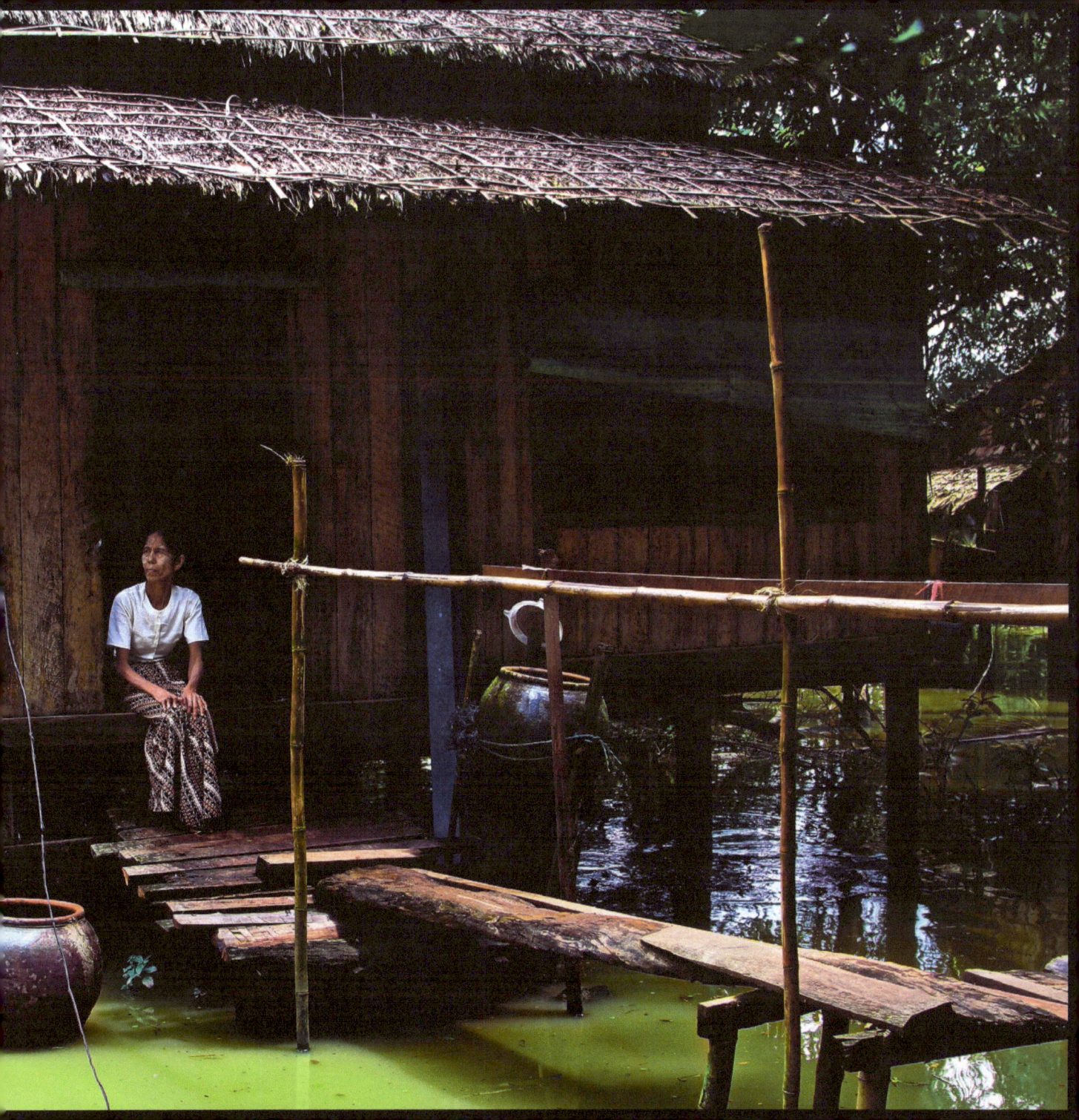

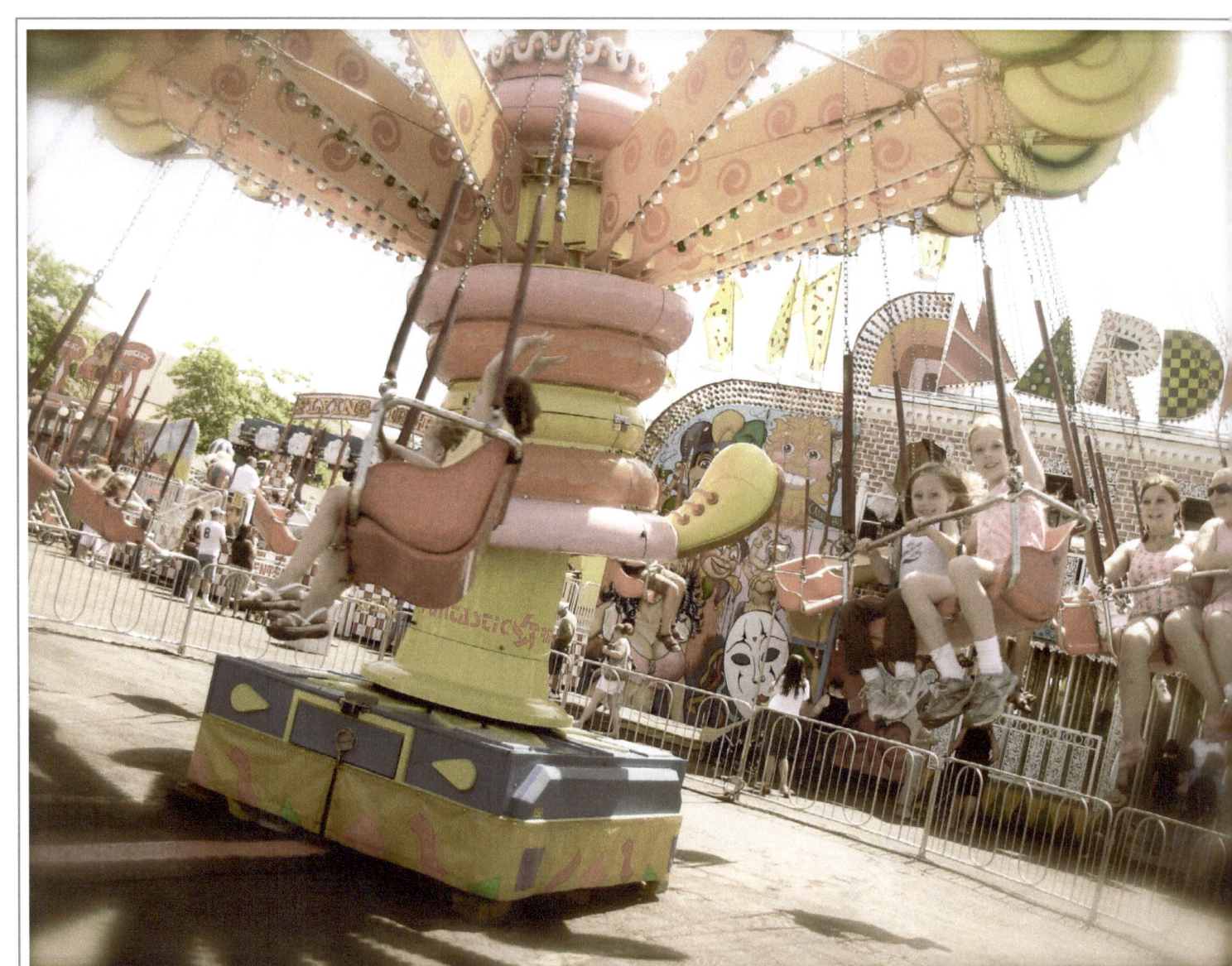

COTTEN CANDY

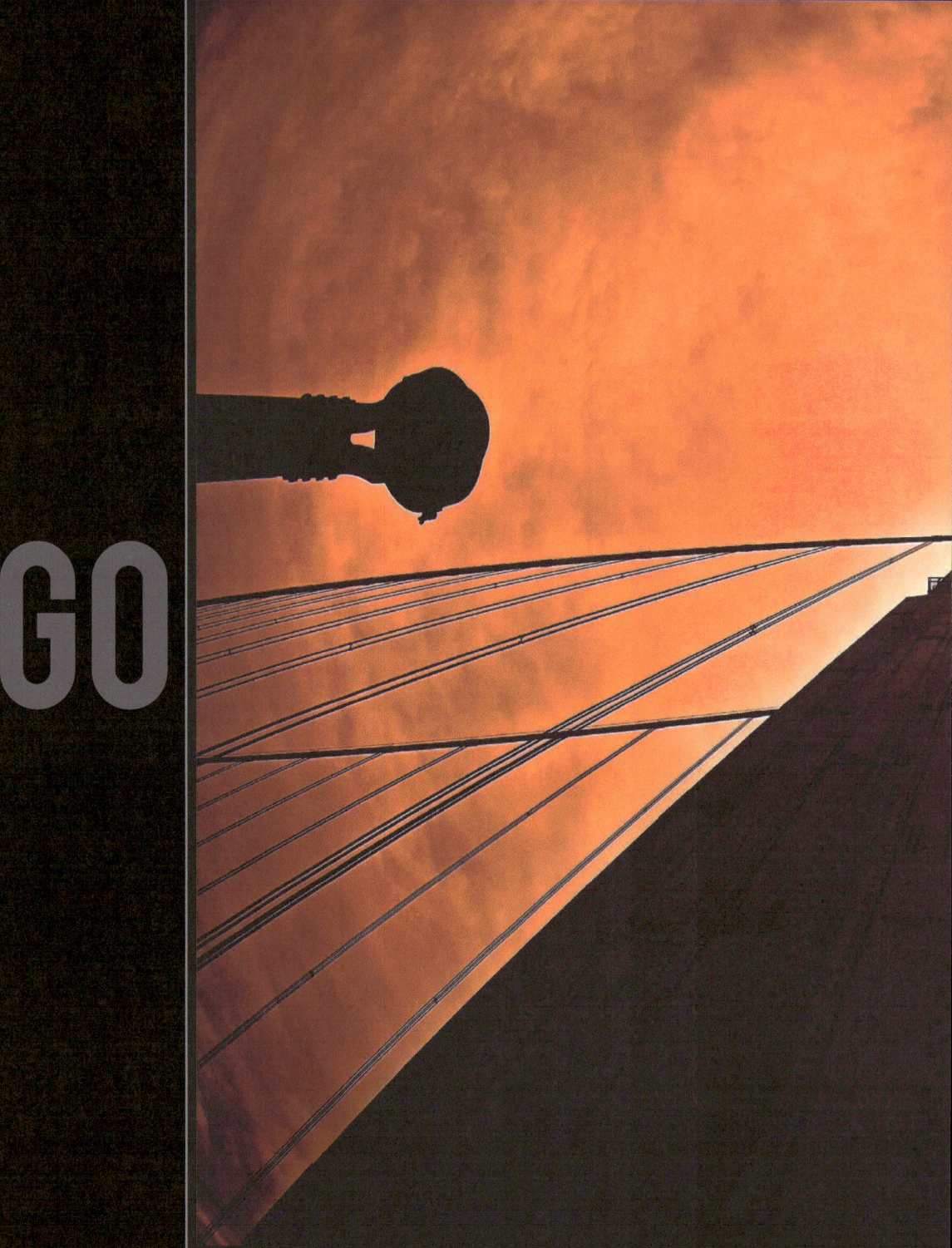

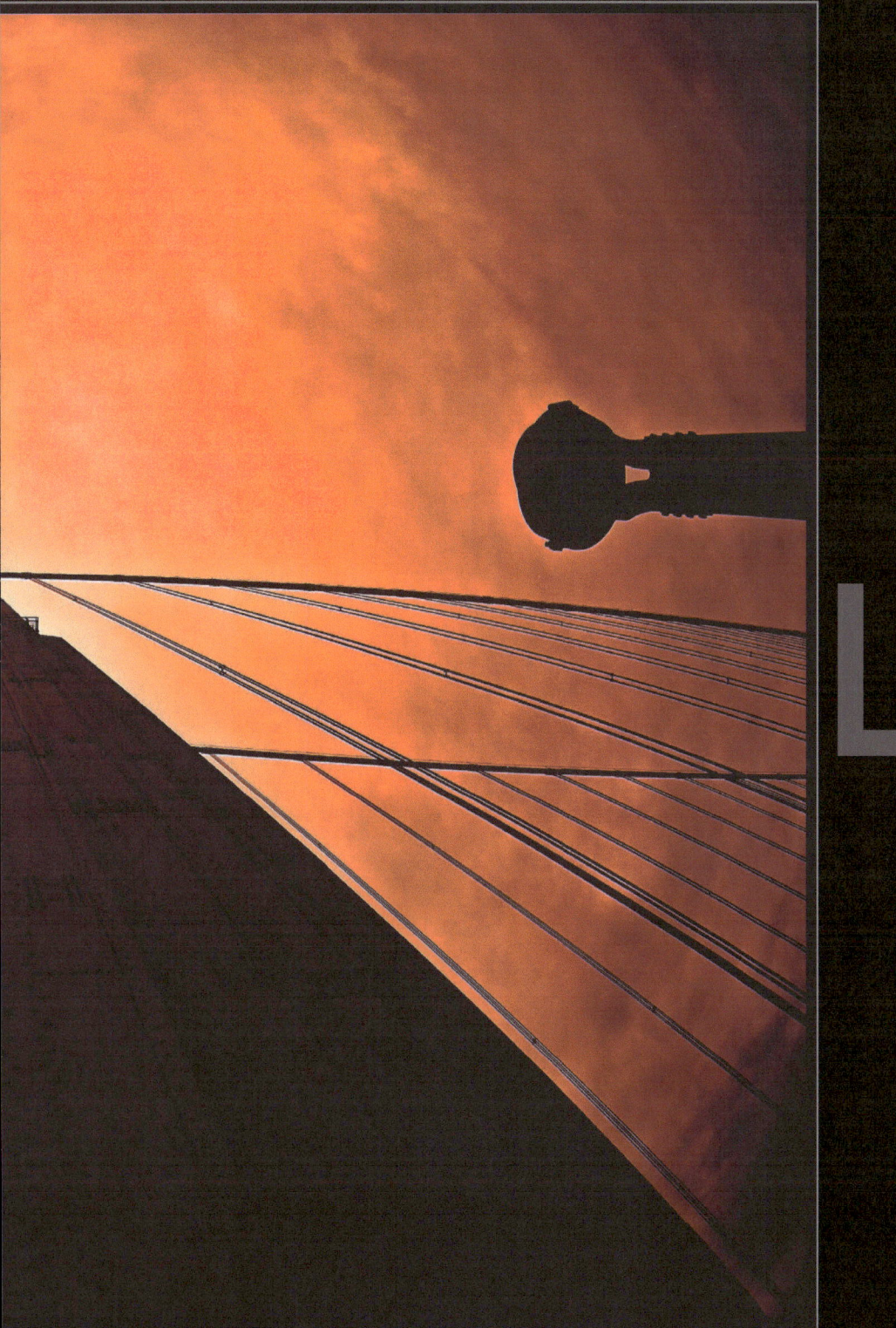

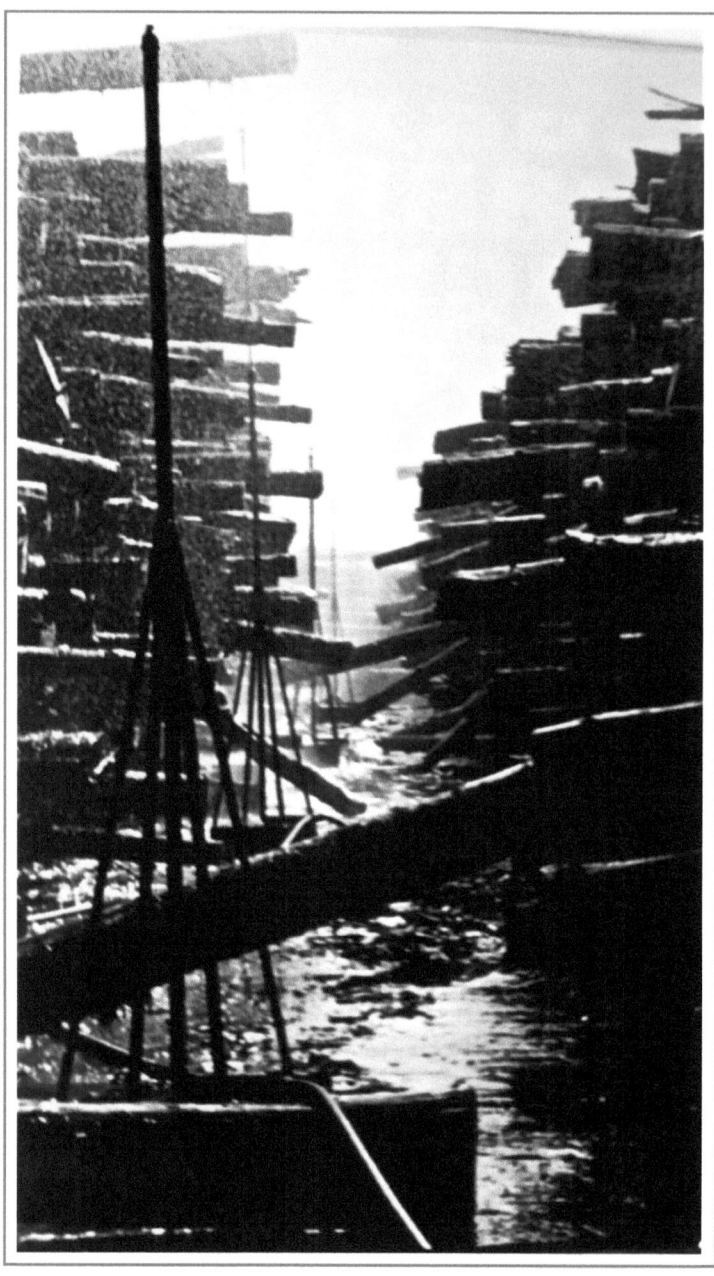

TIMBER

NEWBURYPORT

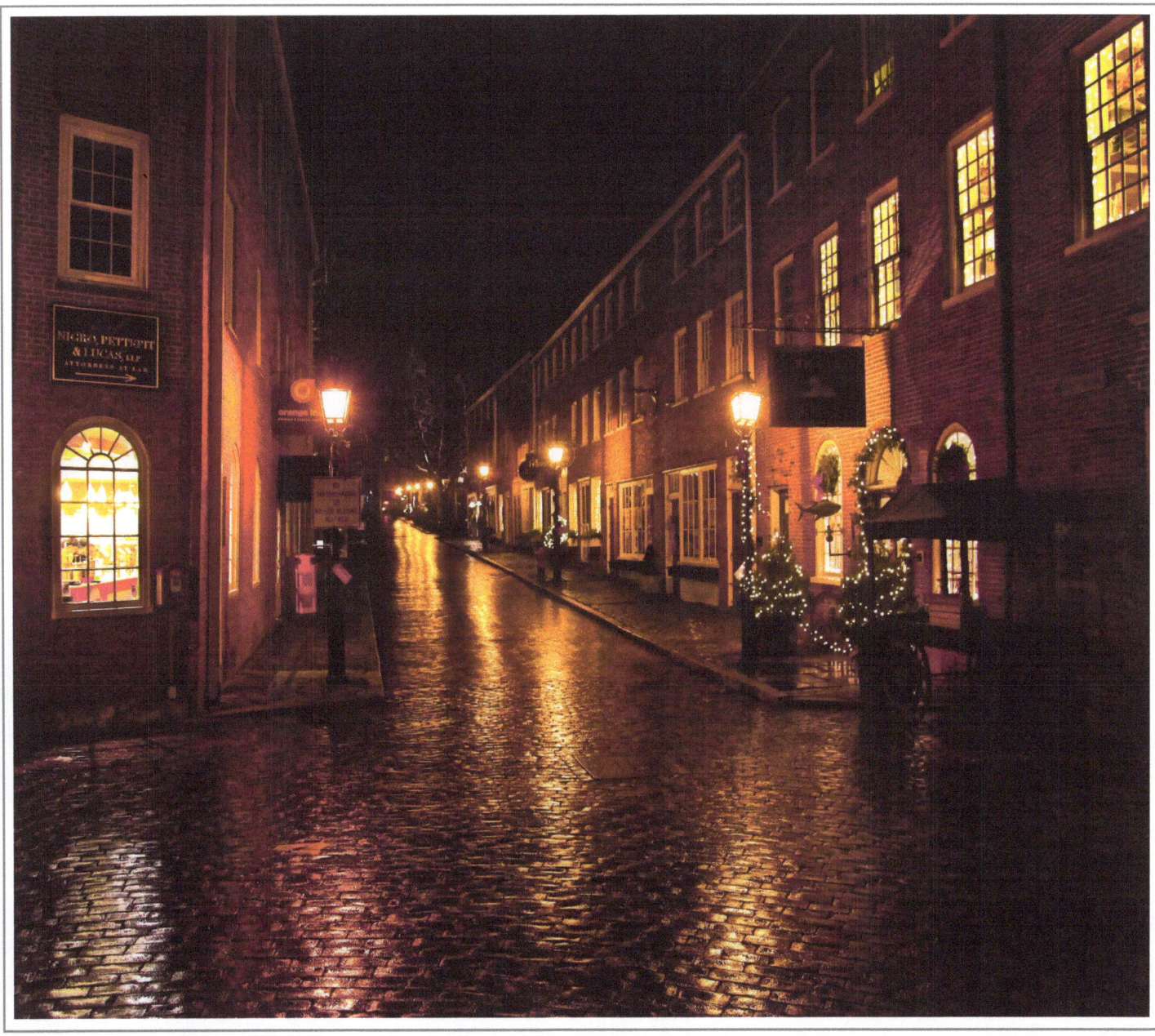

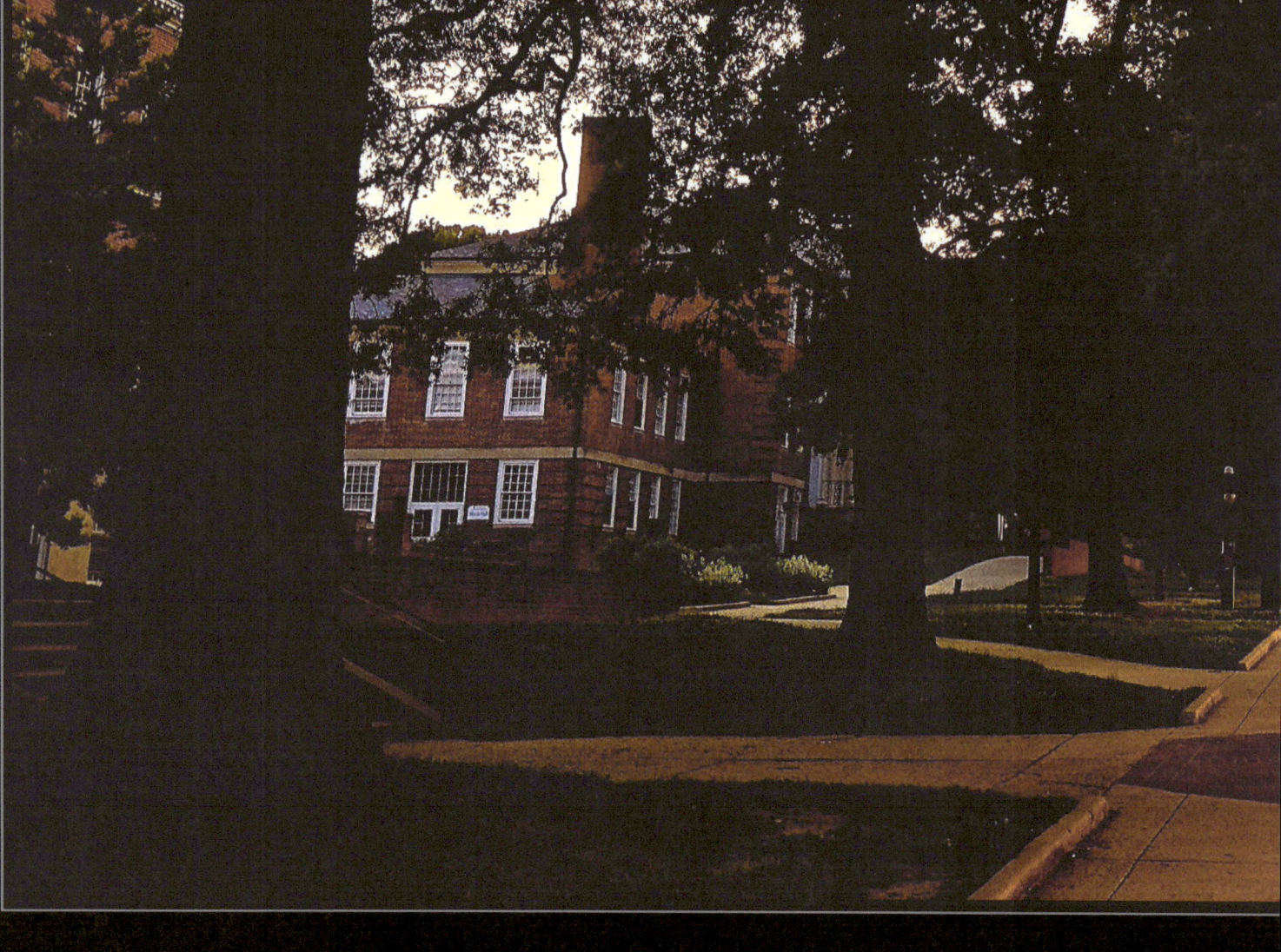

COLLEGE

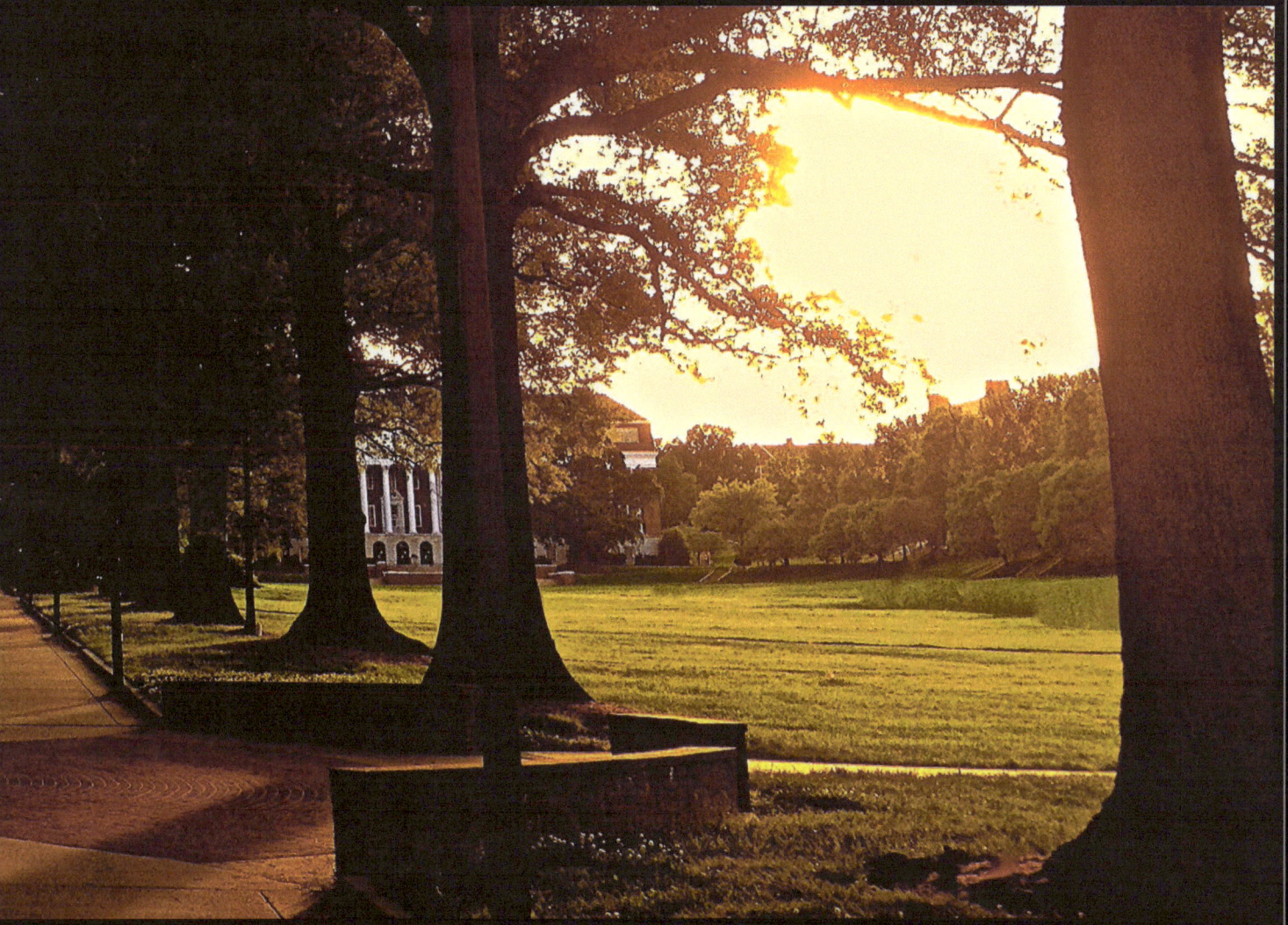

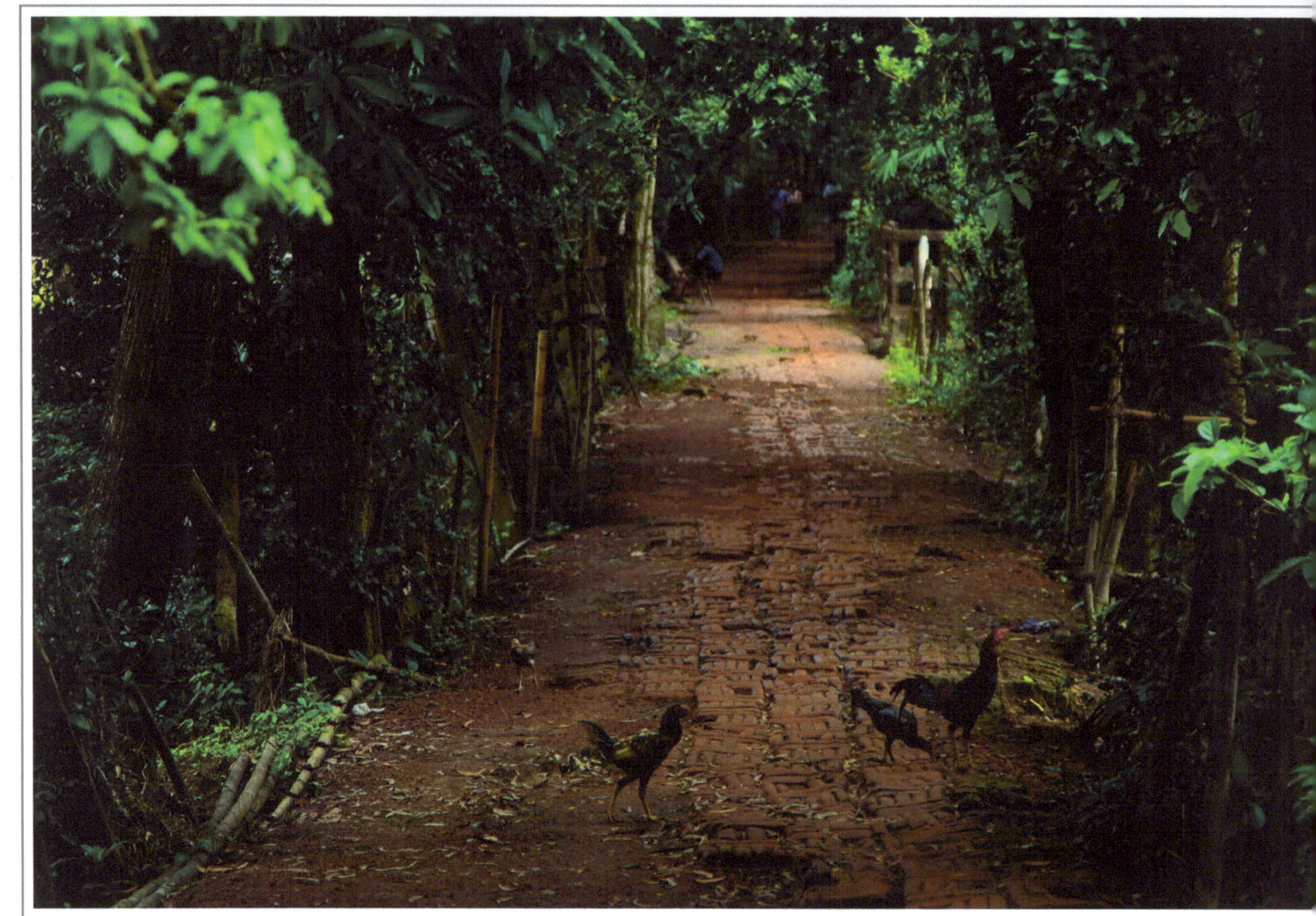

BRICKROAD

HOME#4

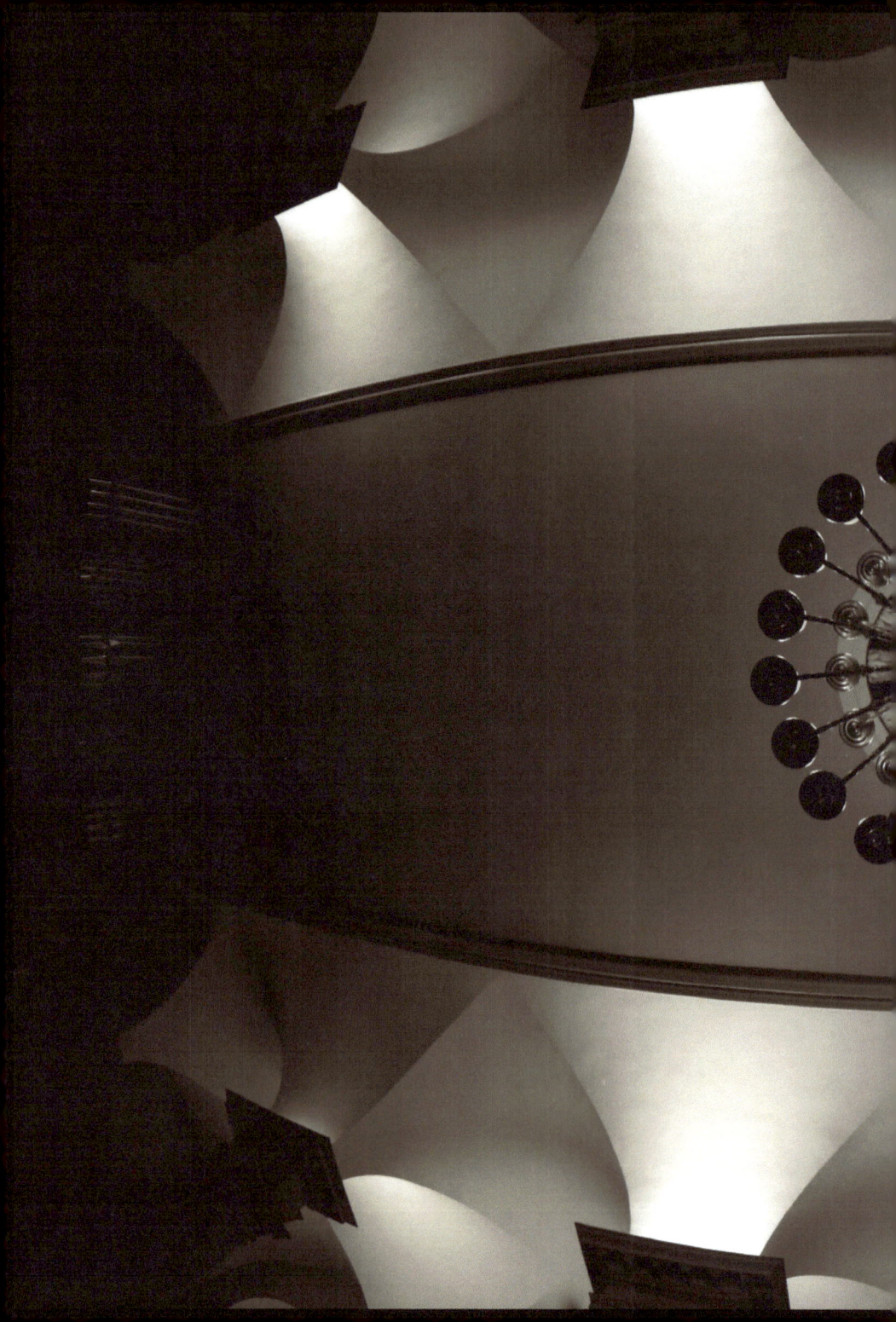

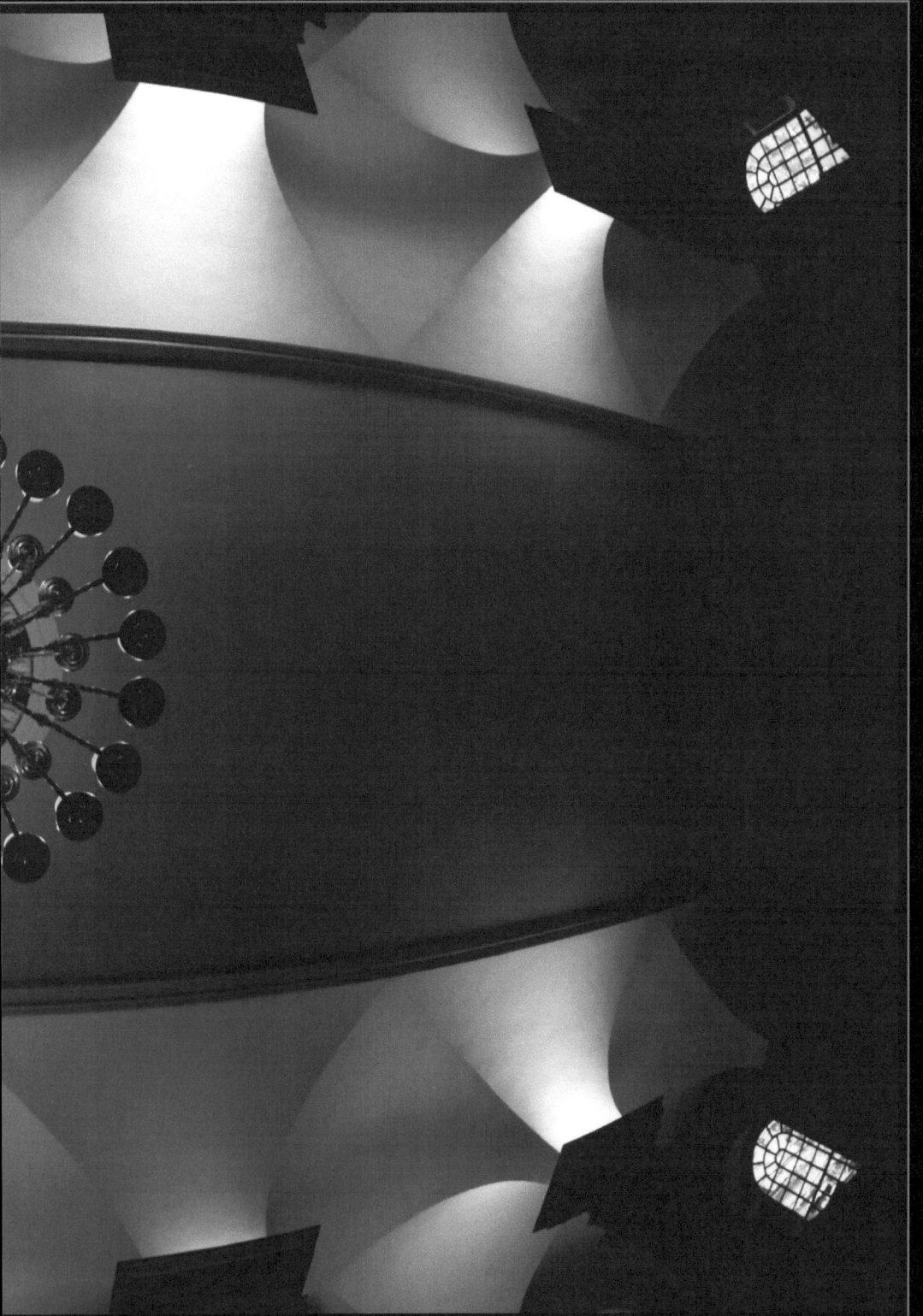

CH
UR
CH

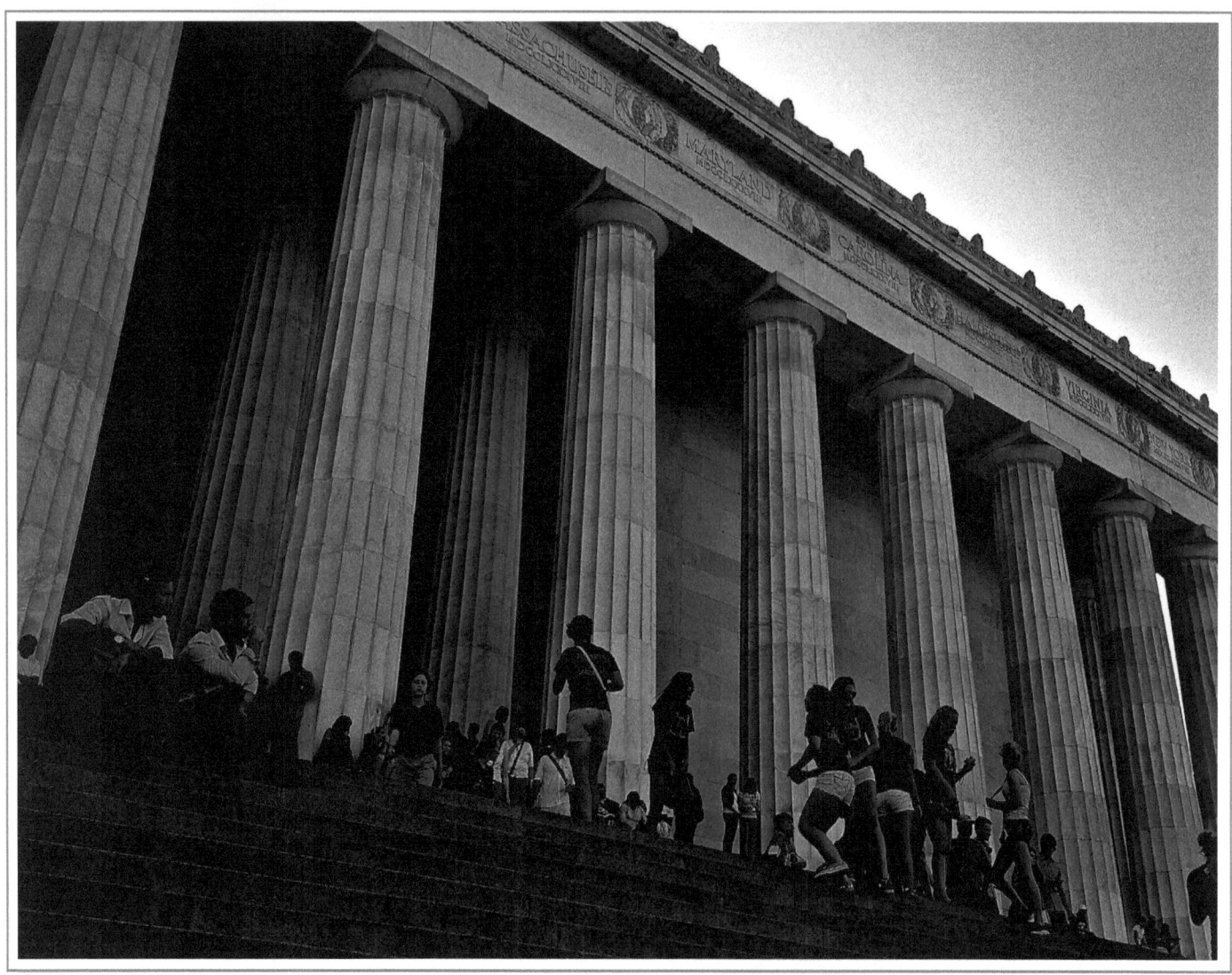

PILLARS#1

PILLARS #2

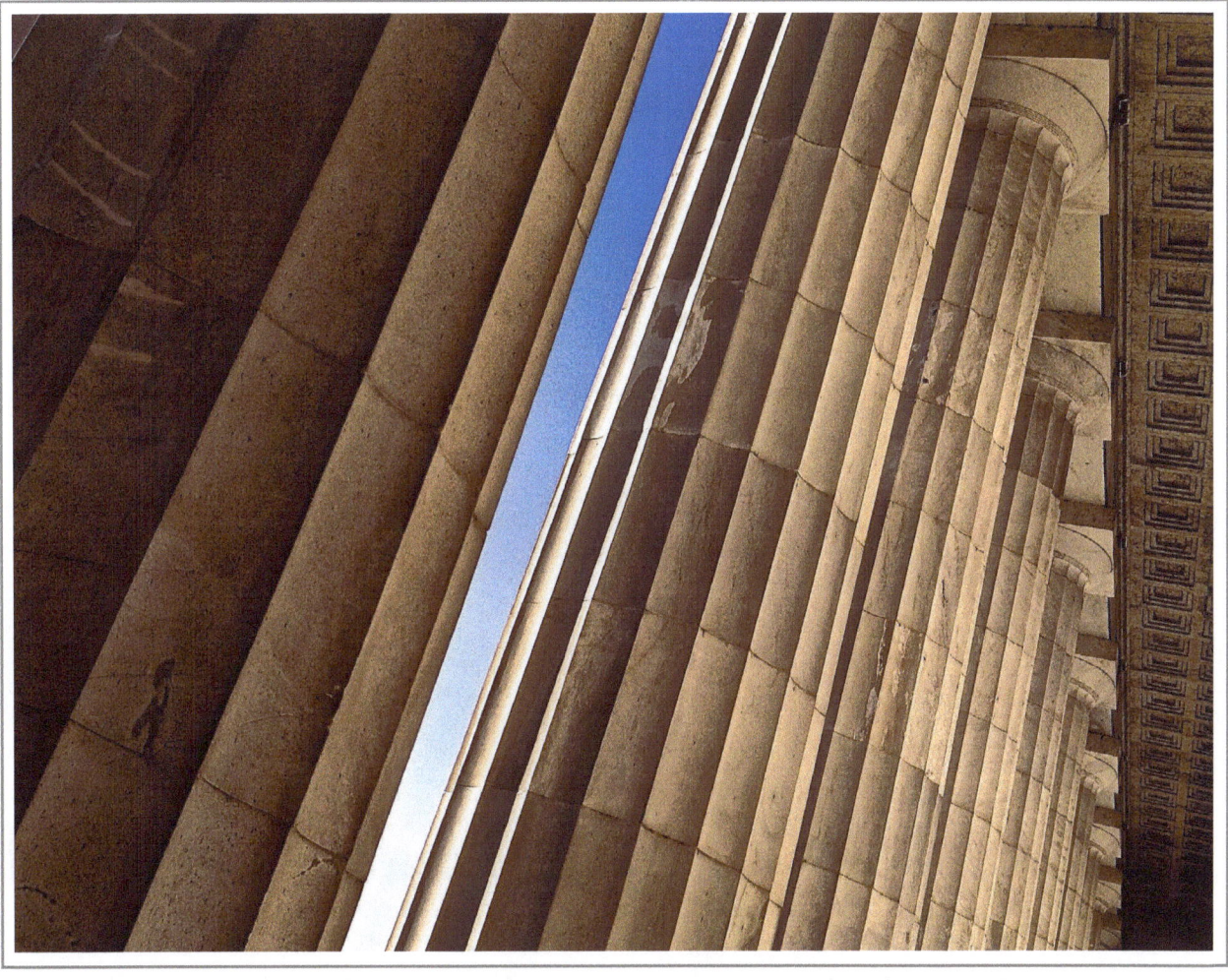

BARB WIRE

SEATTLE

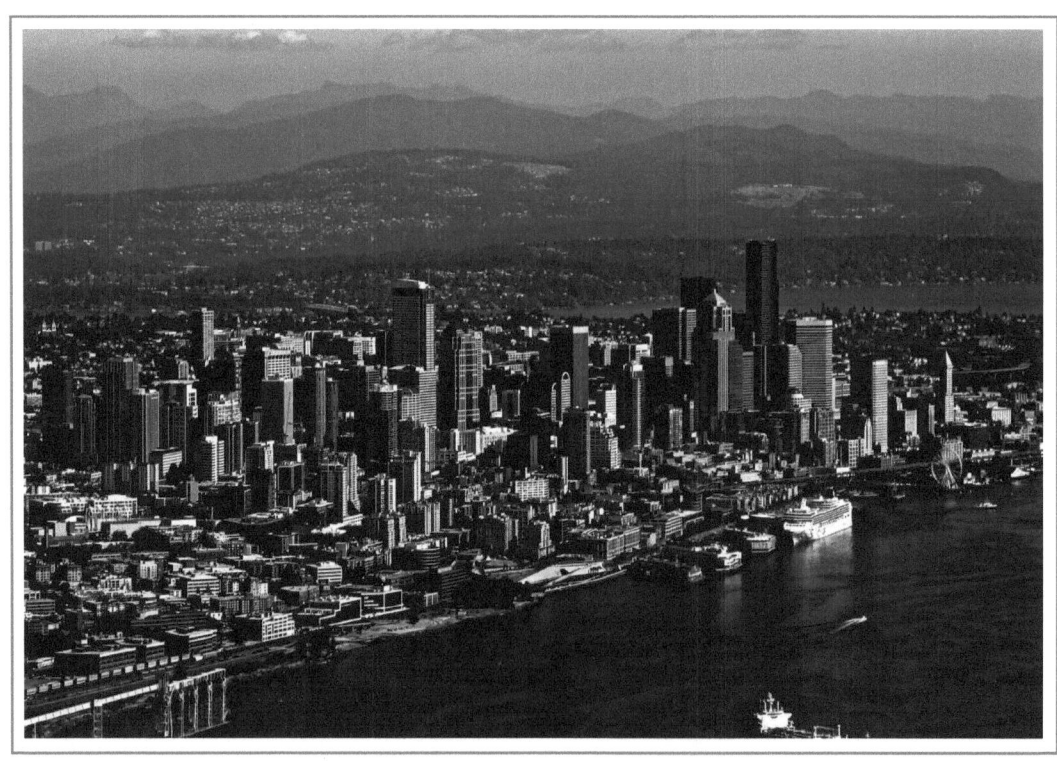

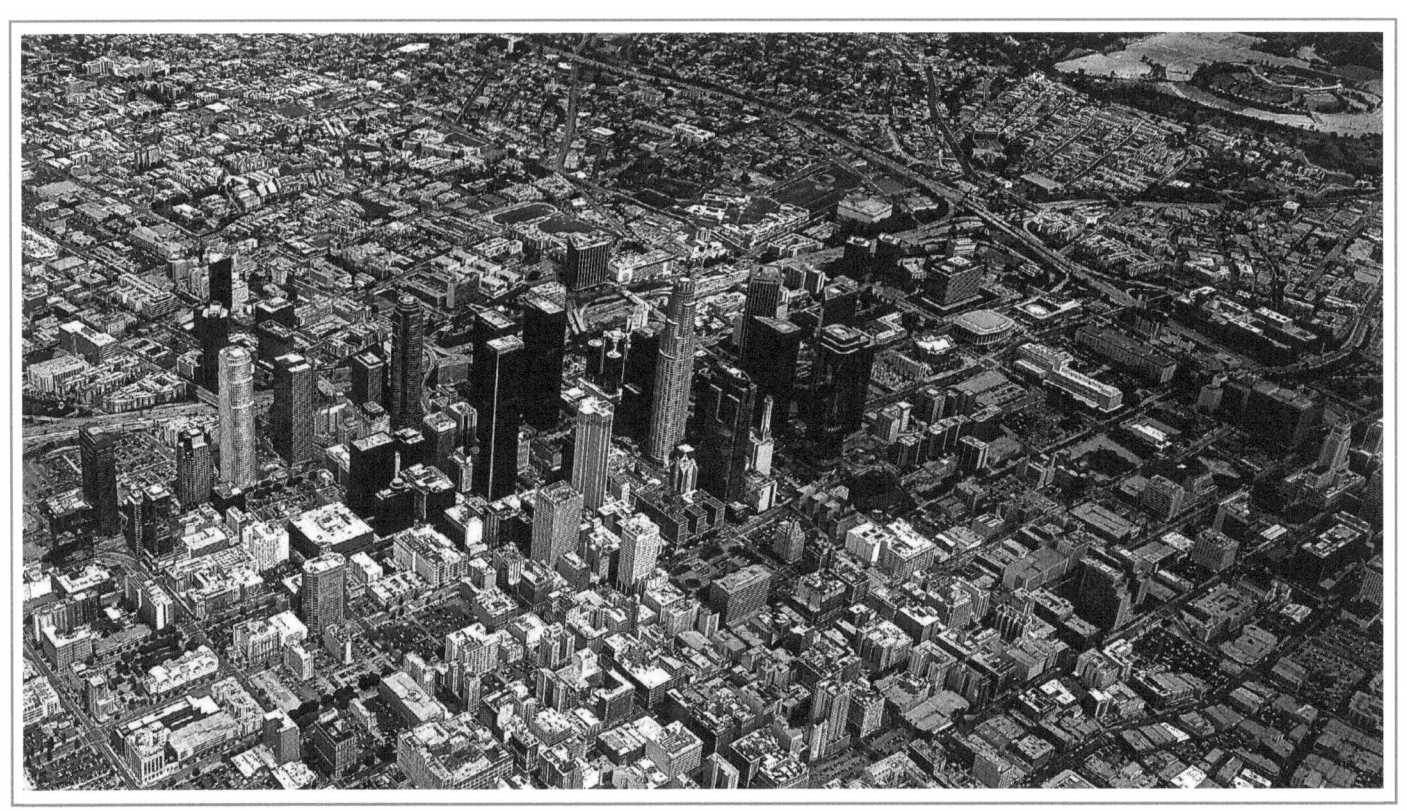

LA

BAREFOOT #2

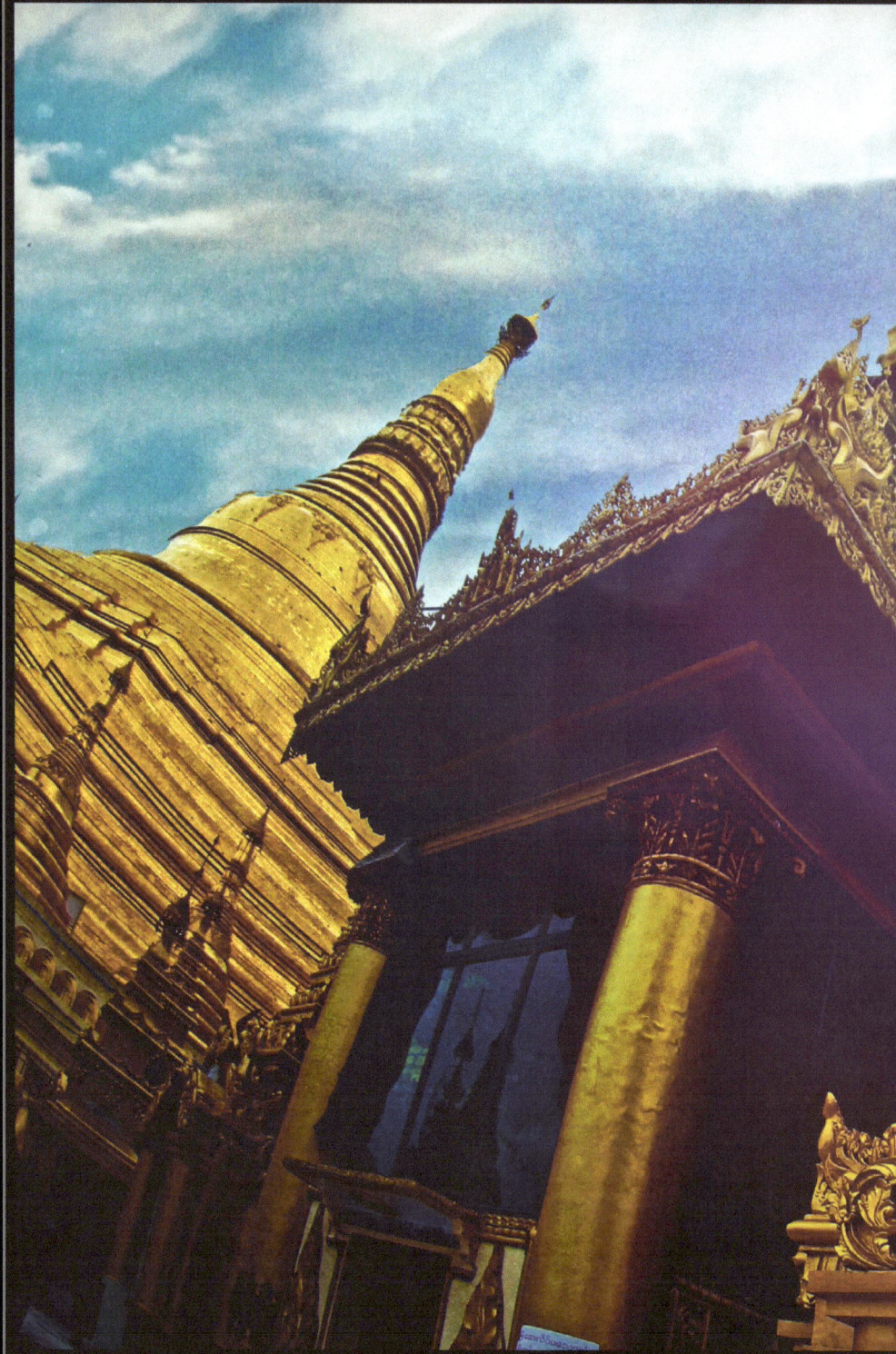

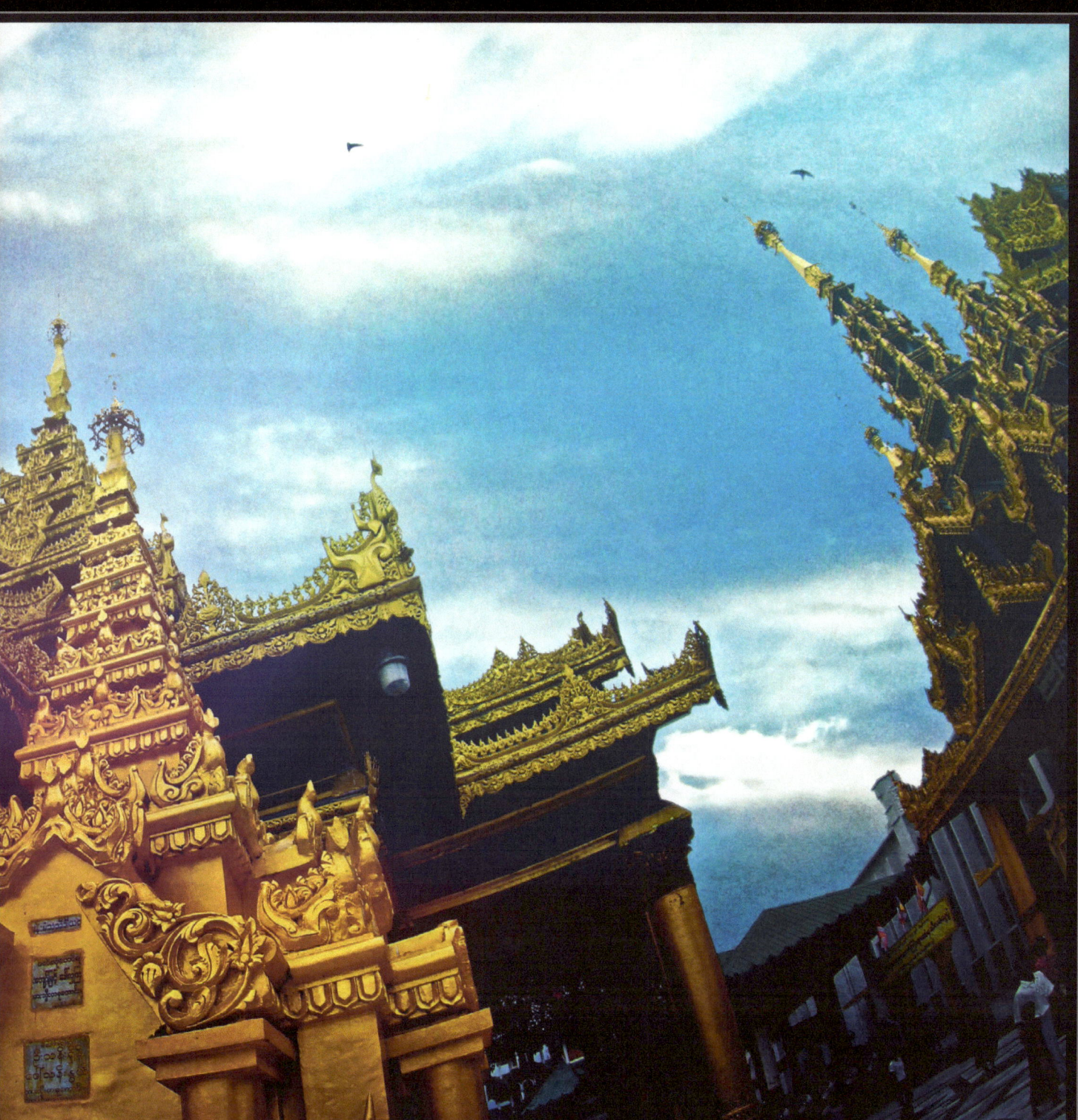

I captured these images between 1999 & 2014 in Asia, North America and Hawaii. Over the last 15 years I've used mostly Canon and Apple gear including a 5D, T2i, C100 and several models of iPhone. I use a range of Canon L lenses and edit my photos with Photoshop and Aperture. My first camera was a Canon Elan II, one of the last popular consumer film SLRs before the introduction of digital.

The introduction portrait of me was captured by Betsy Jaskilka. In the background is Kerry Park, a famous viewpoint for photographing the Seattle skyline. From this viewpoint, the Space Needle appears to be the tallest building in the city, but this is actually an illusion of perspective that can only be seen from the south side of Queen Anne Hill.

Justin Blaney is the #1 bestselling author of 5 books. He lives with his wife and three daughters outside Seattle.

www.justinblaney.com

www.ingramcontent.com/pod-product-compliance
Lightning Source LLC
Chambersburg PA
CBHW040756200526
45159CB00026B/2721